HOW TO DRAW Harry Potter™

Thunder Bay Press
An imprint of Printers Row Publishing Group
A division of Readerlink Distribution Services, LLC
9717 Pacific Heights Blvd, San Diego, CA 92121
www.thunderbaybooks.com • mail@thunderbaybooks.com

Correspondence regarding the content of this book should be sent to Thunder Bay Press, Editorial Department,
at the above address.

Thunder Bay Press
Publisher: Peter Norton
Associate Publisher: Ana Parker
Art Director: Charles McStravick
Senior Developmental Editor: Diane Cain
Editors: Jessica Matteson, Sara Maher
Production Team: Rusty von Dyl, Beno Chan, Mimi Oey

Written, illustrated, and designed by
Creative Giant, Inc. www.creativegiant.net
Mike Thomas, Chris Dickey
Written by Steve Behling
Illustrated by Corina St. Martin

ISBN: 978-164517-360-1

Printed, manufactured, and assembled
in Dongguan, China.

26 25 24 23 22 1 2 3 4 5

HOW TO DRAW Harry Potter ™

THUNDER BAY
P·R·E·S·S

San Diego, California

CONTENTS

5 Introduction

7 Tools

9 Harry Potter

17 Hermione Granger

25 Ron Weasley

33 Hedwig

41 Dobby

49 Buckbeak

57 Albus Dumbledore

65 Minerva McGonagall

73 Severus Snape

81 Lord Voldemort

89 Group Scene

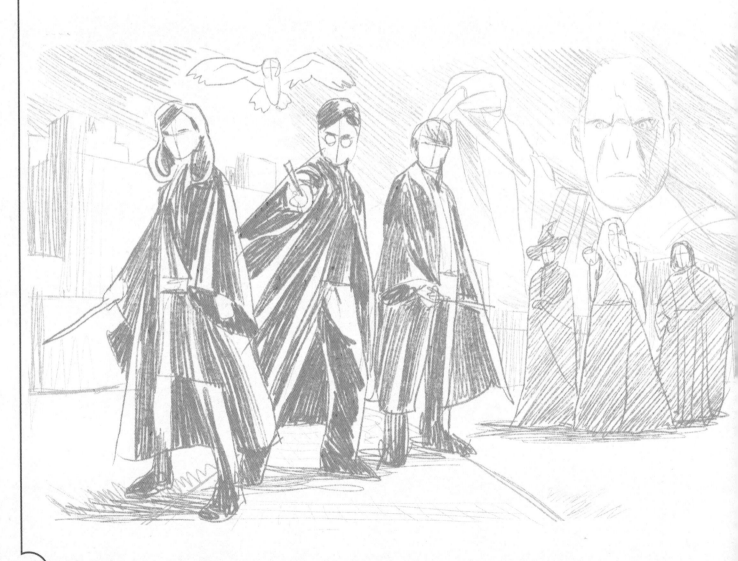

INTRODUCTION

"You're a wizard, Harry."

— RUBEUS HAGRID, KEEPER OF KEYS AND
GROUNDS AT HOGWARTS

When 11-year-old **Harry Potter** heard those words, he learned that he had a place in the wizarding world—an amazing world that would introduce him to the best friends of his life, and throw more magical threats at him than any wizard or witch had ever faced before!

In his first year, Harry meets **Hermione Granger** and **Ron Weasley.** The three become fast friends, and are sorted into Gryffindor house by the Sorting Hat on their first night at Hogwarts School of Witchcraft and Wizardry.

Under the guidance of Headmaster **Albus Dumbledore**, Harry, Hermione, and Ron attend classes taught by such Hogwarts professors as the stern, yet understanding **Minerva McGonagall**, and the stern, yet not remotely understanding (and infinitely more surly) **Severus Snape**. As the school years progress, Harry meets all manner of magical creatures, like a helpful Snowy Owl named **Hedwig**, the well-meaning house-elf, **Dobby**, and a cantankerous Hippogriff called **Buckbeak**.

Trouble always seems to follow Harry and his friends, and they face threats that would make any Muggle (that's a non-magic person) run in the other direction! From the opening of the *Chamber of Secrets* to the return of He Who Must Not Be Named (that's **Lord Voldemort**, in case you were wondering), Harry and his friends would need all their magical skills in order to make it through school.

Now it's time to work your own magic, as you bring Harry, Hermione, Ron, and the other Hogwarts luminaries to life through the strokes of your pencil. In each chapter, we'll introduce a new character, along with step-by-step instructions on how to draw them (and Artist's Notes that will give you additional insight). You'll even learn how to draw backgrounds that are appropriate to the characters, and how to place those characters into each setting.

Oh, yes. We probably shouldn't be telling you this, but you'll also learn how to draw He Who Must Not Be Named. So read on, and prepare to enter a world like no other. Make sure you have your ticket ready as we make our way to Platform Nine and Three-Quarters. We don't want to miss the Hogwarts Express!

TOOLS

While you won't have to worry about picking out your wand at Ollivander's (actually, the wand chooses you, so forget that), you will need to gather some materials as you begin to draw. Art supply stores may appear to be quite humble on the surface, but you'll find that they're quite magical places in their own right. As you read through this section on tools, you might want to spend some time in an art store. Many art stores will let you try the various tools on scratch paper before you buy them, so you can see what they feel like, and find something that's a perfect match for you.

When you're starting out, you'll want to have an assortment of pencils, a pencil sharpener, a couple of good erasers, and a ruler for drawing straight lines.

For pencils, it never hurts to have a good old #2 pencil handy (just like the kind you used for schoolwork). But you'll want to have some others, too. The lead in various pencils will either be H (for "Hard") or B (for "Black"). The harder the lead in the pencil, the duller the line. The softer the lead, the darker the marks will be. When you're drawing, practice holding the pencils gently, and press down on the paper lightly. This will prevent you from breaking pencil tips and having to resharpen every two minutes!

Speaking of sharpening, there are any number of small sharpeners you can get that will put a fine point on your pencils. You might want to have a couple, as they're easy to misplace. And for a ruler, a standard 12-inch will work just fine (but you might also want to have an 18-inch ruler handy, in case you're drawing on larger paper).

TOOLS

Since we're learning how to draw these characters, that makes us students (don't worry about which House you're getting sorted into). And as students, we're bound to make mistakes every now and then. Lucky for us, things such as erasers exist. A lot of artists prefer to use a kneaded eraser. They look like little grey blocks when you buy them, but they're malleable like putty. Kneaded erasers work wonders for removing pencil lines from papers without leaving little eraser crumbs behind. And because you can change the shape of the eraser, you can get into all kinds of tight spots to correct your work, should the occasion arise.

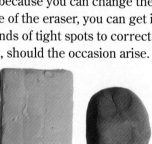

Some paper comes with this book, and we encourage you to work your magic on this as you practice drawing the various characters. But

unless you know a doubling charm, you're eventually going to run out of paper. You can use plain, white printer paper, which can be found in office supply stores. Or, if you're already looking for pencils at the art supply store, you can pick up a sketch pad to practice on. If you're feeling especially ambitious, you can get some higher-quality paper at an art store.

At the end of the day, the tools matter less than your enthusiasm and the fun to be had by drawing. Those are most important, and what you should focus on as you forge ahead!

HARRY POTTER

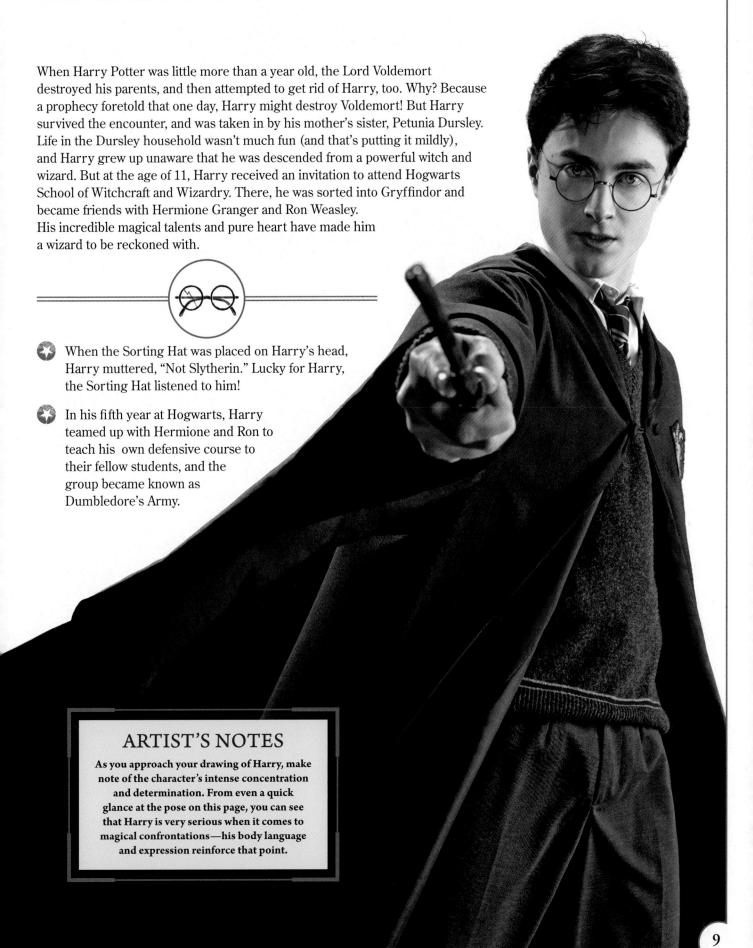

When Harry Potter was little more than a year old, the Lord Voldemort destroyed his parents, and then attempted to get rid of Harry, too. Why? Because a prophecy foretold that one day, Harry might destroy Voldemort! But Harry survived the encounter, and was taken in by his mother's sister, Petunia Dursley. Life in the Dursley household wasn't much fun (and that's putting it mildly), and Harry grew up unaware that he was descended from a powerful witch and wizard. But at the age of 11, Harry received an invitation to attend Hogwarts School of Witchcraft and Wizardry. There, he was sorted into Gryffindor and became friends with Hermione Granger and Ron Weasley. His incredible magical talents and pure heart have made him a wizard to be reckoned with.

- When the Sorting Hat was placed on Harry's head, Harry muttered, "Not Slytherin." Lucky for Harry, the Sorting Hat listened to him!

- In his fifth year at Hogwarts, Harry teamed up with Hermione and Ron to teach his own defensive course to their fellow students, and the group became known as Dumbledore's Army.

ARTIST'S NOTES

As you approach your drawing of Harry, make note of the character's intense concentration and determination. From even a quick glance at the pose on this page, you can see that Harry is very serious when it comes to magical confrontations—his body language and expression reinforce that point.

ROUGH POSE

Your first step will be to establish Harry's pose, which we've based off the picture on the previous page. At this point, we're just using a stick figure, with circles to indicate the right shoulder and knees. Notice how the shoulders and hips are angled. This creates a dynamic feel, like Harry is poised for action. You'll also want to block in Harry's flowing wizard robes.

CREATING FORM

Now it's time to add to the basic structure and create the form of your figure. Using the sticks from the Rough Pose as a "skeleton," flesh out Harry's form by sketching in the lines that will establish his body. You'll also need to sketch in the hairline on Harry's head and lines to indicate his facial features.

ARTIST'S NOTES

In these early stages, you don't need to worry so much about, "Is my drawing perfect?" You're not looking for perfection right now. What you want to do is nail down your character's actions, establish the body language, and make sure all the basic elements of your drawing are in place — in this case, Harry holding his wand with grim determination, ready to defend against some unseen magical threat. Remember, at this point it's more important to show what your character is doing rather than how beautiful your drawing looks.

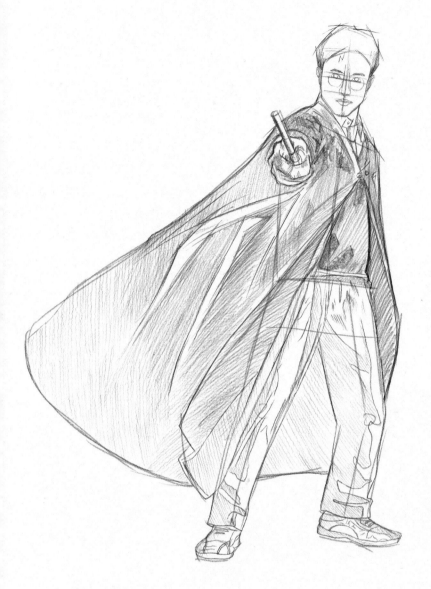

DETAILED DRAWING

So you have your basic figure ready to go. Now you can work your magic and begin to add some details to the figure that will help bring it to life. You'll indicate what kind of clothes Harry is wearing (his school uniform), his Gryffindor robes, his glasses, and the folds and wrinkles in his clothing. And don't forget to indicate the scar (we'll touch on that in Facial Details)!

ARTIST'S NOTES

No doubt you noticed a big change from the drawings on the previous page and where you're at now. What started as a stick figure is now beginning to look like Harry Potter! When you're drawing the face, it's helpful to really study the photograph to make sure you capture the character's essence. You'll want to pay close attention to the space between the eyes and the temples on the sides of his head. A person can look very strange if the eyes are too far apart or too close together. Also note that the line you drew to indicate the eyes will line up with the tops of Harry's ears.

FACIAL DETAIL

Let's zoom in and take a closer look at Harry's face. Delineate the character's eyes, eyebrows, nose, and mouth using the guidelines you established in the Creating Form step. Pay particularly close attention to the lightning bolt-shaped scar on his forehead—the scar he received from Lord Voldemort as an infant.

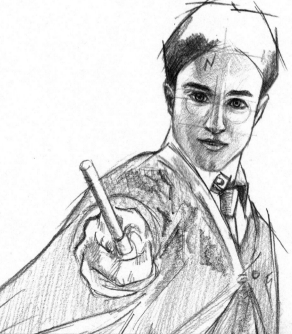

BODY DETAIL

In this stage you can start erasing some of the underlines you used to help get you to this point. You'll also strengthen lines that you made to indicate the character's body and where shadows might fall (like on the legs and robes, particularly on Harry's left side).

ARTIST'S NOTES

Harry purchased his first wand from Ollivander in Diagon Alley. And though we can't see the phoenix feather at the wand's core, we know how special Harry's wand is. Note how you indicated the wand with a line in the first step. Flesh it out by drawing a cylindrical shape. And as you shade the wand, make sure you follow the wand's contours.

ARTIST'S NOTES

To prevent getting any pencil smudges on your drawing, you might want to place a blank piece of paper between your hand and the drawing. (Unless you know the spell Evanesco and can make those smudges vanish!)

TEXTURES

As you work on the figure, look closely at the photograph on page 9, taking a look at the texture of Harry's clothing. You want to capture that feel as much as possible in your drawing. Think about how the material of Harry's robes differs from that of his shirt or pants.

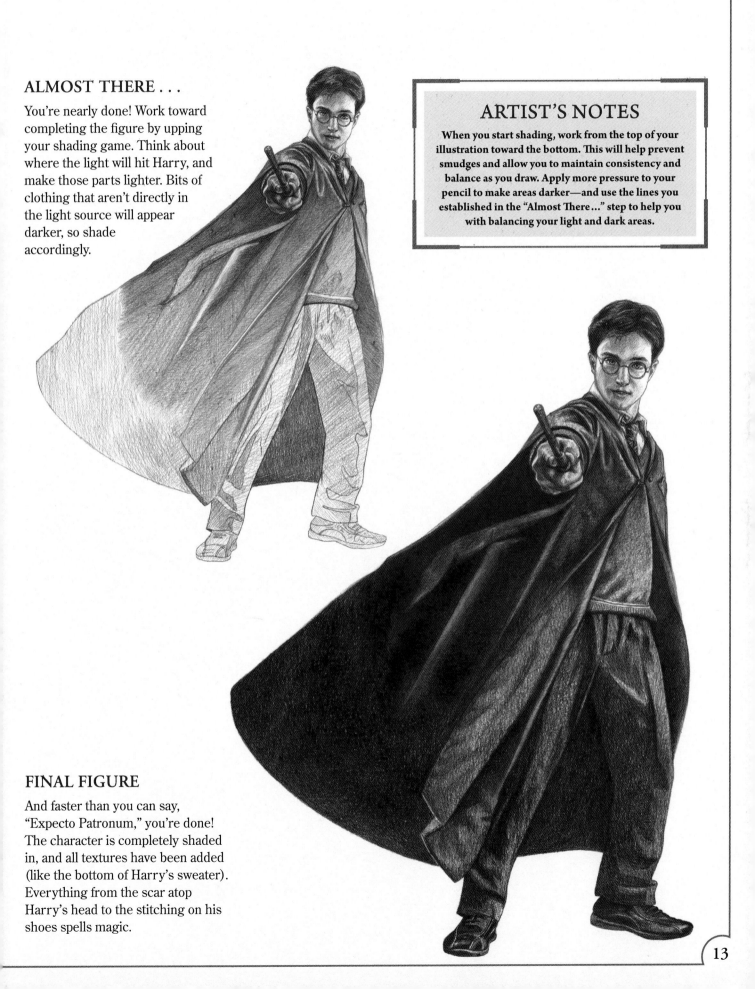

ALMOST THERE . . .

You're nearly done! Work toward completing the figure by upping your shading game. Think about where the light will hit Harry, and make those parts lighter. Bits of clothing that aren't directly in the light source will appear darker, so shade accordingly.

ARTIST'S NOTES

When you start shading, work from the top of your illustration toward the bottom. This will help prevent smudges and allow you to maintain consistency and balance as you draw. Apply more pressure to your pencil to make areas darker—and use the lines you established in the "Almost There…" step to help you with balancing your light and dark areas.

FINAL FIGURE

And faster than you can say, "Expecto Patronum," you're done! The character is completely shaded in, and all textures have been added (like the bottom of Harry's sweater). Everything from the scar atop Harry's head to the stitching on his shoes spells magic.

HARRY POTTER

REFERENCE

You've finished Harry in his defensive pose, but…what is he defending? How about Hogwarts itself? It's time to work on the background, and we'll start by checking out some photo references of the school. Though the image you see here may look quite complex, don't be discouraged. You won't need to draw each and every little detail. What you want to do is absorb the essence of the photo, and distill it in your sketch.

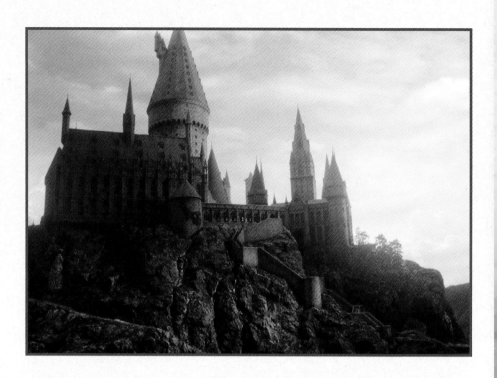

ROUGH LAYOUT

Using simple shapes, break down Hogwarts into its essential parts. The building structure (use rectangles and trapezoids), the towers (cones), as well as the grounds. This doesn't have to be some elaborate 3D drawing—a simple 2D approach will work just fine here.

STRUCTURE

Once you have the basic shapes in place, you can start adding all the little details that help define Hogwarts. You can use the photo as reference, but think about how you might simplify the design as you go. You don't have to draw every single little line; indications for windows or rocks will do perfectly.

Keep in mind that if your scene will have a figure in front, like Harry will be here, don't draw the background lines too dark. You'll need to erase them to place your figure. We're showing you the whole background so that you can draw any character you want in front of it once you've completed the book!

SHADING AND DETAILS

Just like you did with Harry, you'll want to shade your background drawing to give it a sense of life. Think about the light source (where light is coming from) and the different textures of the various building materials.

ARTIST'S NOTES

You can replicate and suggest the terrain surrounding Hogwarts through clever use of shading. By varying light and dark areas, you can define areas that will give your drawing a sense of volume. In this way, you won't have to draw each and every little rock that you see in the photo, and you'll still end up with a background drawing that any witch or wizard would be proud of.

COMPOSITION

Once you have your background looking just the way you want it, you can composite the figure of Harry Potter with the background. Turn the page to get an idea of what that will look like!

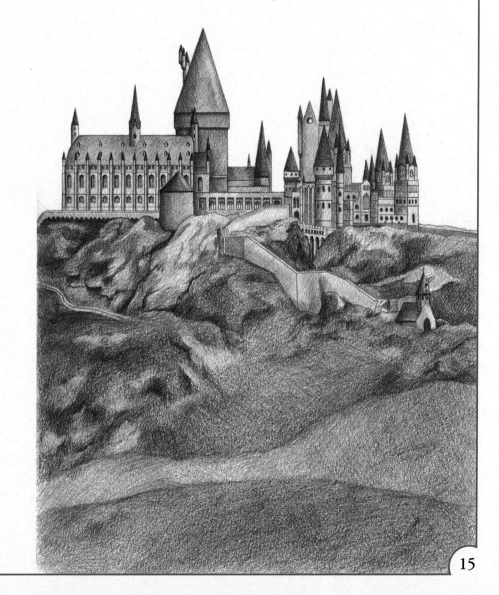

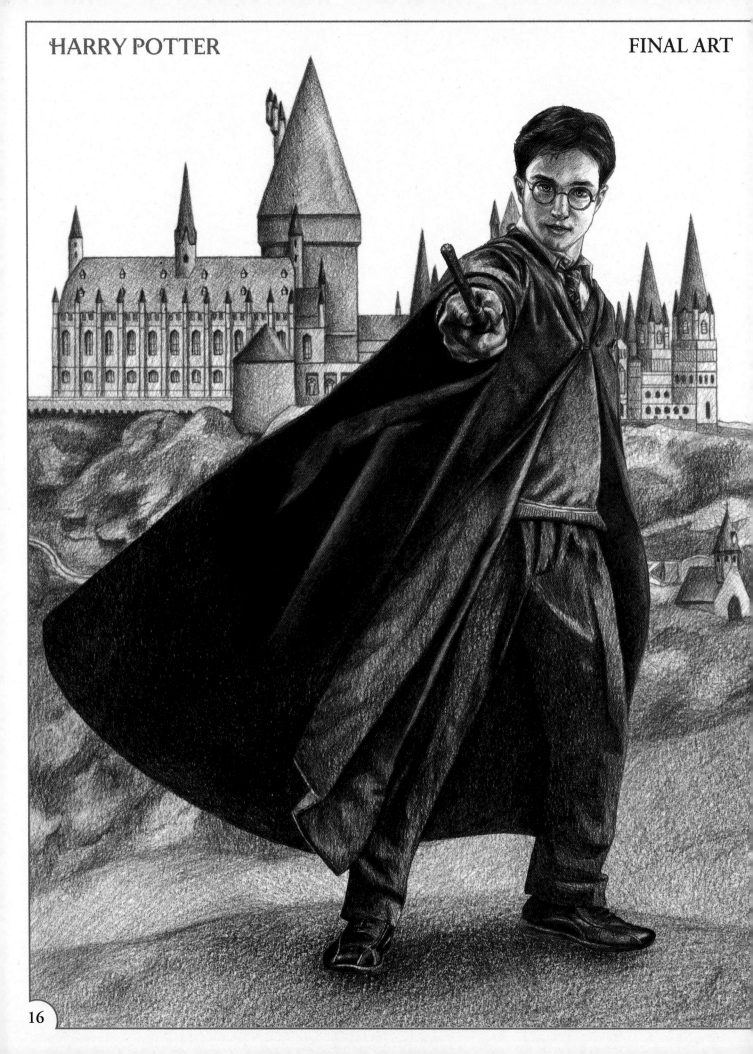

HERMIONE GRANGER

Born to Muggle parents, Hermione Granger discovered that she was, in fact, a witch. Accepted into the Hogwarts School of Witchcraft and Wizardry, she first encountered fellow students Harry Potter and Ron Weasley on the Hogwarts Express bound for the school. Sorted into Gryffindor along with Harry and Ron, Hermione quickly became a stand-out student. Not only did she excel in all her classes, but Hermione proved to be unflinchingly loyal to her friends, and brave in the face of danger (which pretty much surrounded the trio all the time).

* A talented witch, Hermione displayed an aptitude for the craft at a young age. Before she arrived at Hogwarts for her first year, she knew some spells—she was even able to fix Harry's broken glasses on the Hogwarts Express!

* In Hermione's third year, Professor McGonagall gave the bright student a Time-Turner. The device made short-term time travel possible. Being the awesome student she was, Hermione used it to take extra courses.

ARTIST'S NOTES

When drawing Hermione, it's important to take all aspects of her character into consideration. Everything from her stance, to her facial expression, to what she's wearing plays a key role in how she's depicted. Every line says something about her personality, and what she might be thinking or feeling.

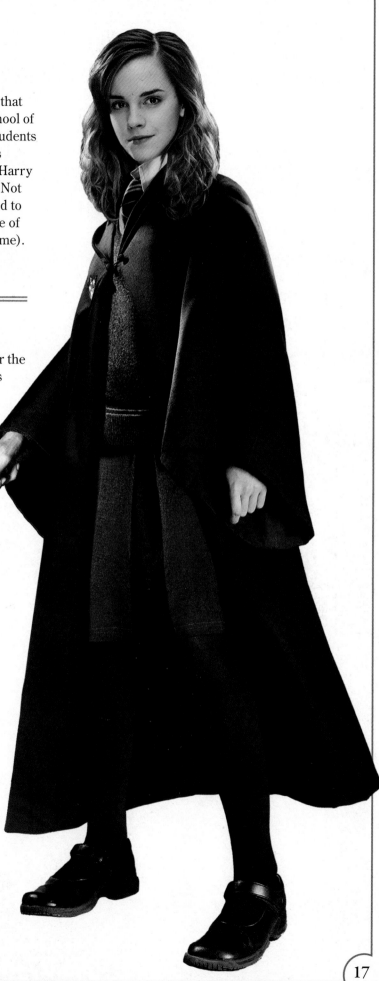

HERMIONE GRANGER

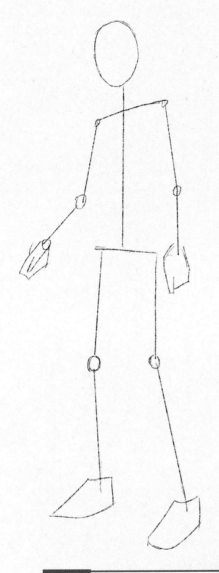

ROUGH POSE

Hogwarts students are required to wear robes during the course of their studies. When drawing Hermione, you'll want to make sure this detail is correct. But before you get to that, you'll need to make sure that the basic body structure—the character's anatomy—beneath the robes is correct. We'll talk more about that in the Artist's Notes below.

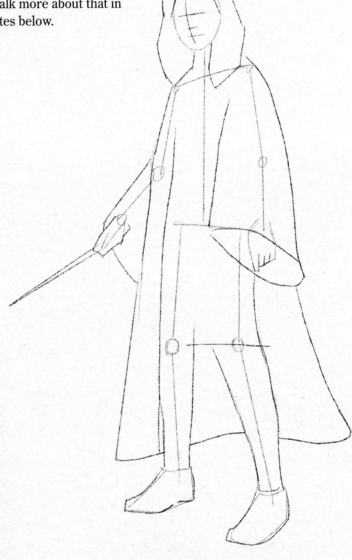

ARTIST'S NOTES

Here's a simple step-by-step instruction on how to draw the rough pose. Draw an oval for the head, and a stick figure from the neck down, including the shoulders and hips. Unless your pose is front-facing, the hips and shoulders will typically be asymmetrical. This is called contrapposto, when the arms and shoulders contrast with the hips and legs.

Note how one side of Hermione's hips appears to sit higher than the other—same with her shoulders. This adds balance to your drawing.

Next, loosely draw in the legs, arms, hands and feet.

Remember, at the first step, you're looking for the correct placement of things rather than making them well defined.

CREATING FORM

Working over your stick figure, add in the main areas of mass—sleeves, hair, and the shapes of the legs, shoulders, and arms. Start to add in where important details will be, like fingers, the wand, and her face.

DETAILED DRAWING

At this point you'll want to be emphasizing key details in your drawing. For example, focus on delineating Hermione's features, as well as the curls in her hair. Add small details to the wand to make it less smooth and to bring out its wooden appearance. You'll erase any sketchy lines from the previous step as you finalize the character's expression, pose, and costume details.

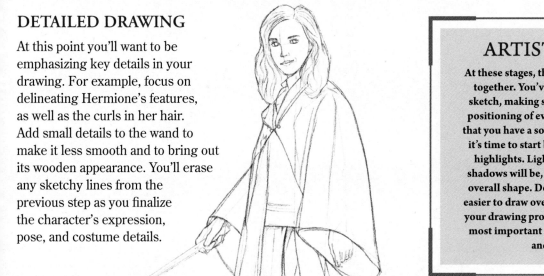

ARTIST'S NOTES

At these stages, things are starting to come together. You've completed the overall sketch, making sure the proportions and positioning of everything is correct. Now that you have a solid foundational drawing, it's time to start blocking in shadows and highlights. Lightly draw in where your shadows will be, paying attention to their overall shape. Do this lightly at first—it's easier to draw over or erase certain areas as your drawing progresses. This is one of the most important stages, so take your time and have fun!

FACIAL DETAIL

Now you're ready to embellish Hermione's facial characteristics. Pay particular attention to the shape of her eyes, and the curves of her nose and mouth. Note the very slight smile on Hermione's face—even when she's facing the most sinister of opponents, she never loses her humor, nor her spirit.

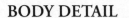

HERMIONE GRANGER

BODY DETAIL

As we move on from the head, keep in mind exactly how the shadows will fall on Hermione's robes, as well as the various folds and wrinkles in the fabric.

TEXTURES

At this point, in addition to the shadows and folds you added on the previous step, you'll be focusing on the textures of the clothing. What kind of fabric is it? What would it feel like if you were to touch it? Keep these thoughts in mind as you continue to add detail to your drawing.

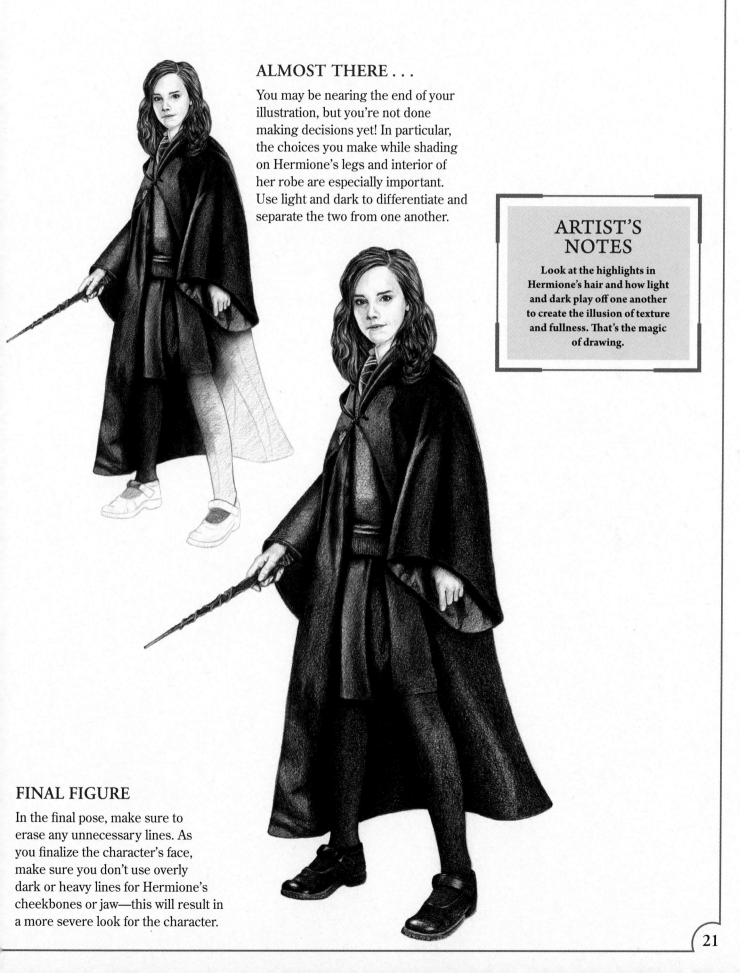

ALMOST THERE . . .

You may be nearing the end of your illustration, but you're not done making decisions yet! In particular, the choices you make while shading on Hermione's legs and interior of her robe are especially important. Use light and dark to differentiate and separate the two from one another.

ARTIST'S NOTES

Look at the highlights in Hermione's hair and how light and dark play off one another to create the illusion of texture and fullness. That's the magic of drawing.

FINAL FIGURE

In the final pose, make sure to erase any unnecessary lines. As you finalize the character's face, make sure you don't use overly dark or heavy lines for Hermione's cheekbones or jaw—this will result in a more severe look for the character.

HERMIONE GRANGER

REFERENCE

Once you finish your figure, it's time to think about setting. Where would Hermione be? There are countless locations that are appropriate to the character—for example, the Gryffindor common room, the Great Hall, or, as we see here, a classroom.

ARTIST'S NOTES

This is where you can get really creative. Using the above photo as inspiration, pick and choose the details you want to feature in your background. Don't worry about trying to capture every single little thing in your drawing. Just focus on the elements you think are important. To communicate a classroom setting, you might want to include a desk, as well as the walls and windows that you see in the photo. Remember, this is about capturing a mood. Here we've decided to use the lead-glass window to frame our drawing's star.

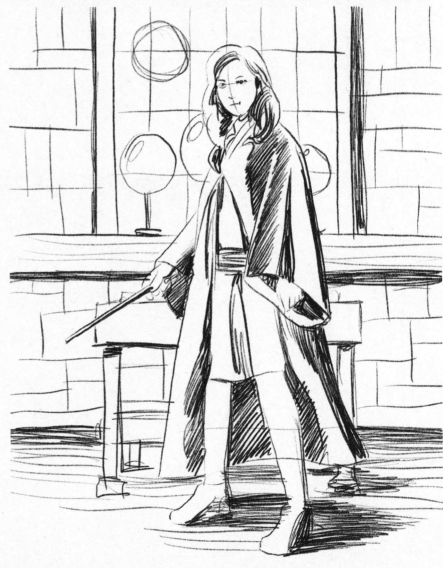

ROUGH LAYOUT

Compose your drawing by placing your figure precisely where you want it. From there, sketch in the background details like we talked about above. At this stage, don't worry about getting all the details just right—it's more important that you decide where everything goes first!

STRUCTURE

Now's the time where you're going to want to break out your ruler! Using your photo for reference and inspiration, begin adding the various lines that will make up the walls and window in your background. You'll want to delineate the desk as well. The ruler will help you keep everything straight!

SHADING AND DETAILS

You can bring your background to life through the addition of shading and texture (just like you did with the figure). Shade the edges of each brick, keeping the centers relatively open. If you're going to color your work, leave more white area for the color to show.

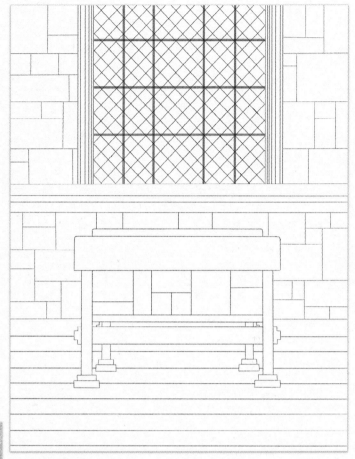

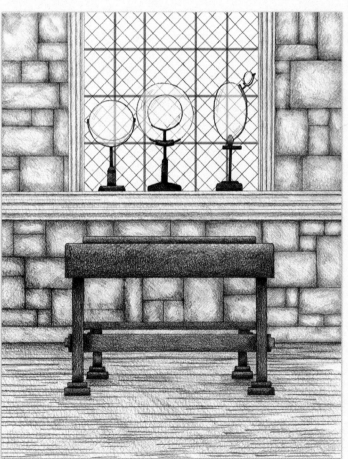

ARTIST'S NOTES

As you did with Hermione's clothing, observing the way light falls on objects in your own home can help with your drawing. See what happens when you turn on a light, and how the shadows fall on furniture and the walls. What do the textures look like? How (and where) do shadows appear on the floor? Incorporate what you observe into your drawing.

COMPOSITION

You've got a figure, you've got a background—now it's time to put it all together. Make sure your character remains the center of attention. You might have drawn a stupendous desk, but Hermione is the showcase of your illustration. Add a shadow at her feet to connect her to the scene.

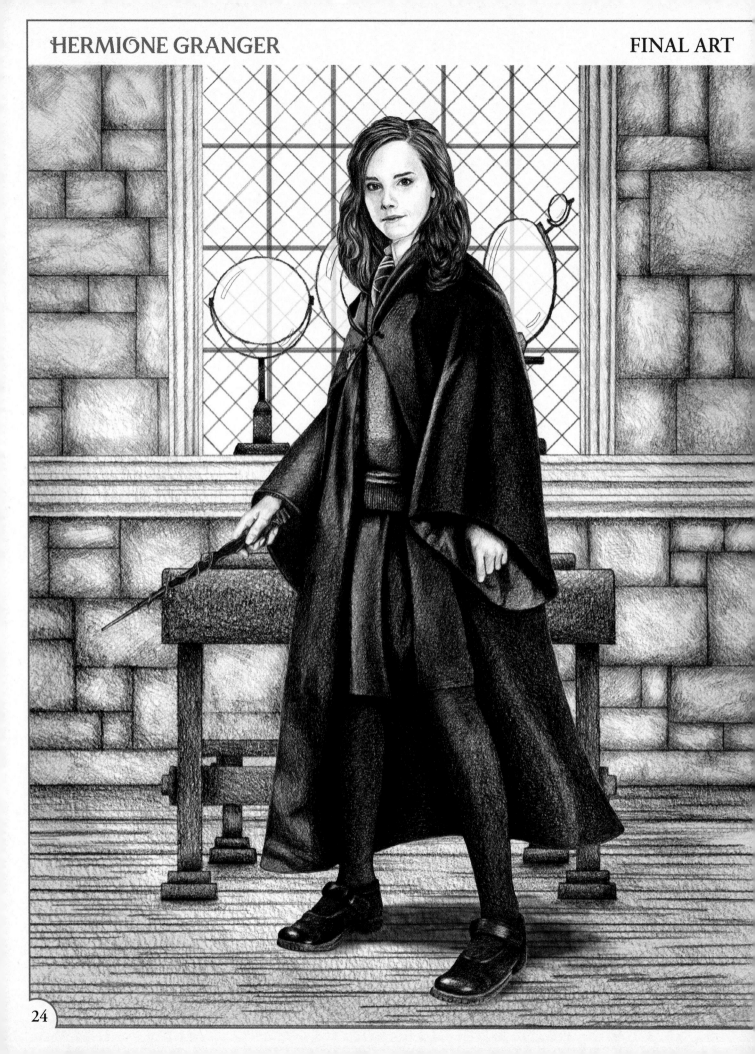

RON WEASLEY

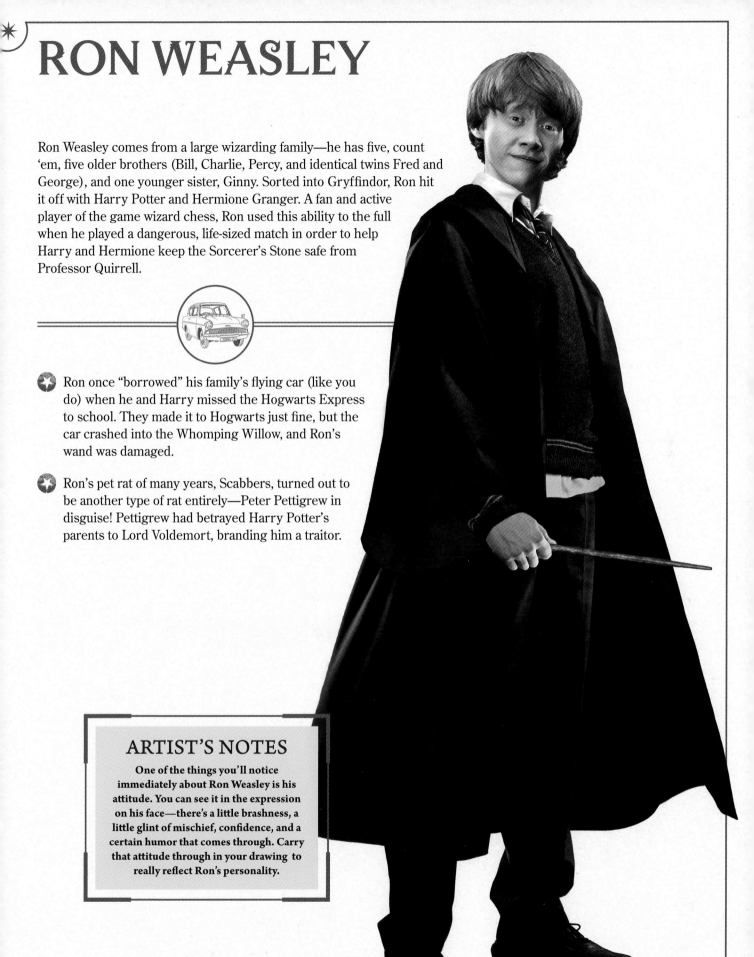

Ron Weasley comes from a large wizarding family—he has five, count 'em, five older brothers (Bill, Charlie, Percy, and identical twins Fred and George), and one younger sister, Ginny. Sorted into Gryffindor, Ron hit it off with Harry Potter and Hermione Granger. A fan and active player of the game wizard chess, Ron used this ability to the full when he played a dangerous, life-sized match in order to help Harry and Hermione keep the Sorcerer's Stone safe from Professor Quirrell.

⭐ Ron once "borrowed" his family's flying car (like you do) when he and Harry missed the Hogwarts Express to school. They made it to Hogwarts just fine, but the car crashed into the Whomping Willow, and Ron's wand was damaged.

⭐ Ron's pet rat of many years, Scabbers, turned out to be another type of rat entirely—Peter Pettigrew in disguise! Pettigrew had betrayed Harry Potter's parents to Lord Voldemort, branding him a traitor.

ARTIST'S NOTES

One of the things you'll notice immediately about Ron Weasley is his attitude. You can see it in the expression on his face—there's a little brashness, a little glint of mischief, confidence, and a certain humor that comes through. Carry that attitude through in your drawing to really reflect Ron's personality.

RON WEASLEY

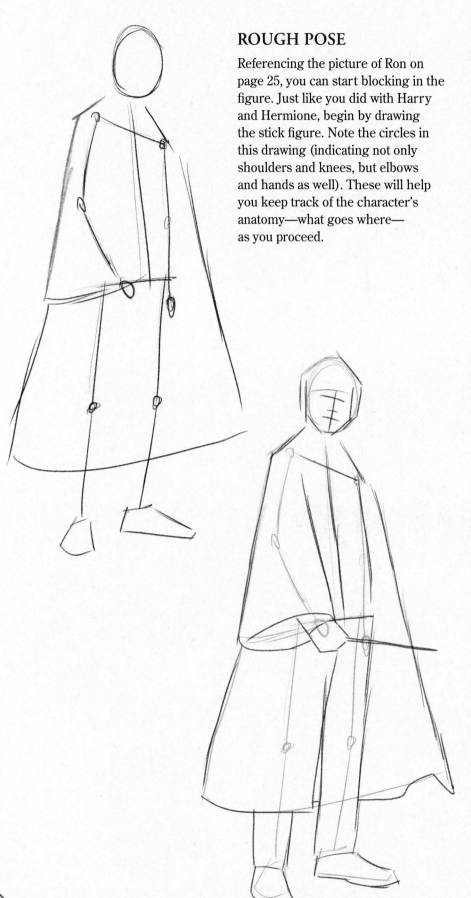

ROUGH POSE

Referencing the picture of Ron on page 25, you can start blocking in the figure. Just like you did with Harry and Hermione, begin by drawing the stick figure. Note the circles in this drawing (indicating not only shoulders and knees, but elbows and hands as well). These will help you keep track of the character's anatomy—what goes where— as you proceed.

Referencing the picture of Ron on page 25

ARTIST'S NOTES

If you take a look at the first step, you'll see that Ron's left hand and arm are indicated in the drawing, pressed right up against the left side of his body. But in the second step, they're gone. What happened? A bit of magic from Professor McGonagall's Transfiguration class? Hardly. When you're moving from step to step, you're going to make adjustments as you go. In order to get the character's anatomy just right, it's important to block in the complete figure at first. But as you move along, you can eliminate details. This is the difference between a drawn pose that matches the photo reference and a sketch that makes you say, "Why does his left side look weird? What happened to his arm?"

CREATING FORM

Once you have the basic shape, you can start defining the figure a bit more as you erase some of the lines from the previous step. As you sketch in shapes to indicate the character's robes, be aware that there's a person underneath. The sleeve hangs down, but the arm bends slightly to the right. That's why you drew the circle back in the first step, so the bent arm looks natural.

DETAILED DRAWING

Start sketching in the various lines and contours of Ron's clothing, as well as the character's face and hair. When you're working on the hair, observe the photo reference and see which way it parts. In Ron's case, the hair sweeps mostly over the left side of his face, with a little messiness in the middle. This creates a tousled look that's particular to Ron.

FACIAL DETAIL

Working off the sketched-in details from the last step, you can concentrate more of your time on getting Ron's facial expression just perfect. Note the attitude in the photo reference on page 25, especially the slightly raised eyebrow over his right eye, and the playful smirk on his face. Make sure the hair on the right side of his face doesn't cover the eyebrow—we need to see it!

ARTIST'S NOTES

As you're working on your characters' faces, keep in mind that their eyes are actually spheres—they're not flat circles. Spend some time looking in a mirror, and study your own eyes so you see their shape and how they appear in the context of your face. Do the same with the photo reference so you really get a sense of the character's appearance. Then, when you're drawing that part of the face, sketch in a circle where the sphere of the eye will be.

RON WEASLEY

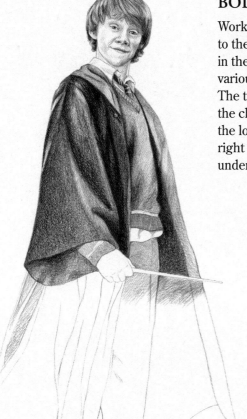

BODY DETAIL

Working from the top of the figure to the bottom, you can start to add in the shading and better define the various creases in Ron's wardrobe. The trick here is to keep track of the character's arms and legs—note the long crease running down Ron's right sleeve. This indicates his arm underneath the robes.

ARTIST'S NOTES

As you're drawing in shadows and adding shading, always keep in mind where the light is coming from and how strong the light source might be. For example, if Ron casts the Lumos charm, then the light will come from the tip of his wand. Anything close to the light will not be cast in shadow, while things farther away or untouched by the light will appear dark.

TEXTURES

Keep working your way down, completing more and more of the shading and contouring on your figure. Remember that the details can make your drawing! With that in mind, make sure that Ron's sweater is slightly pulled up, and we see his rumpled, untucked shirt beneath.

ARTIST'S NOTES

All the work you did in the first couple of steps will be on display here, and you'll have achieved an awesome bit of magic. Your eye will think there's a body under those robes! The figure will have real weight and volume. And the more you draw, the more you'll master this magical feat.

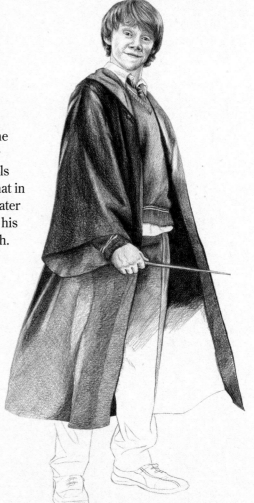

ALMOST THERE . . .

You're very nearly finished with the figure. At this stage of the game, you'll want to focus your attention on the character's lower half. Concentrate on the texture of the pants and the interior of the robes.

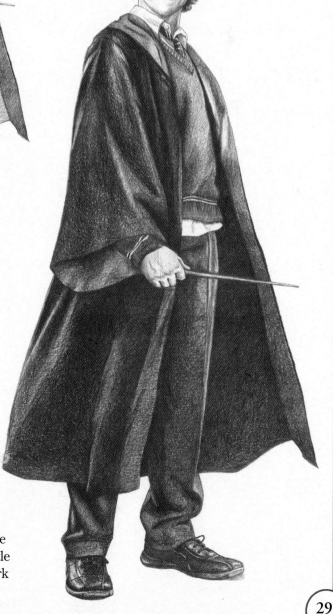

ARTIST'S NOTES

Don't be afraid to go back and erase any lines that you're not happy with. Nothing is permanent! You can keep making changes at every step until the drawing looks exactly the way you want it.

FINAL FIGURE

And just like that, you have a completed figure! This is a good time to take a step back and look at your drawing as a whole. If you see any areas that could use a little more attention (a little shading here, a little lightening there), go ahead and work your magic.

RON WEASLEY

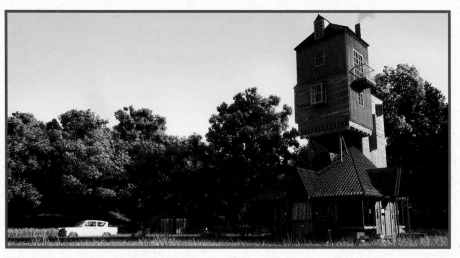

REFERENCE

When you think about the Weasleys, one of the places that comes to mind almost immediately is The Burrow, the family home. The house looks almost cobbled together from several different homes, and tilts at odd angles. It's supported by magic, and the perfect place for the happy, family-oriented Weasleys to call home. And it's the perfect setting for your figure of Ron!

ARTIST'S NOTES

When you sketch in The Burrow, one of the first things you'll notice is the combination of organic and rigid shapes. You've got an entire forest of trees behind the family home, with lots of curves, and then the house itself, with lots of straight lines. A successful drawing will balance these elements, and really help the Burrow to stand out.

ROUGH LAYOUT

As you start your sketch, use the photo of The Burrow as inspiration. That means you don't have to reproduce everything exactly as you see it! You can decide how close you are to the house, and how much of it you want to show. It might be the wizarding world, but it's **your** world, too!

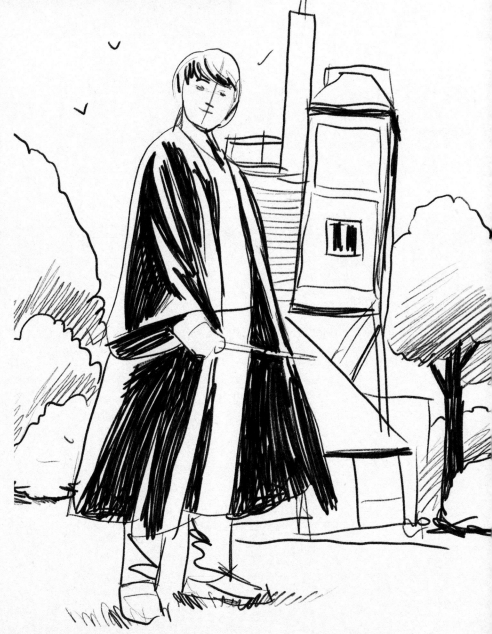

STRUCTURE

Once you're happy with your rough background sketch, start to refine the structure and better define the building, as well as the trees.

SHADING

Begin to delineate the various elements. Note the bricks on the chimney—darkening some bricks while leaving others light creates depth.

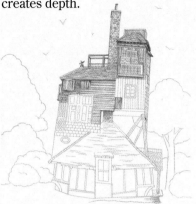

DETAILS

At this point, you'll work on shading all the little bits and pieces that make the Burrow what it is—the wood, rooftop, windows, and more.

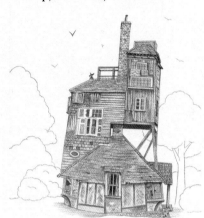

SCENERY

With the house almost exactly the way you want it, now you need to focus on the scenery. Shade in the trees and foliage surrounding the home.

COMPOSITION

You're almost ready to add Ron to your drawing! Sketch in the lawn. And when you add Ron, remember to ground the figure, like you did with Harry.

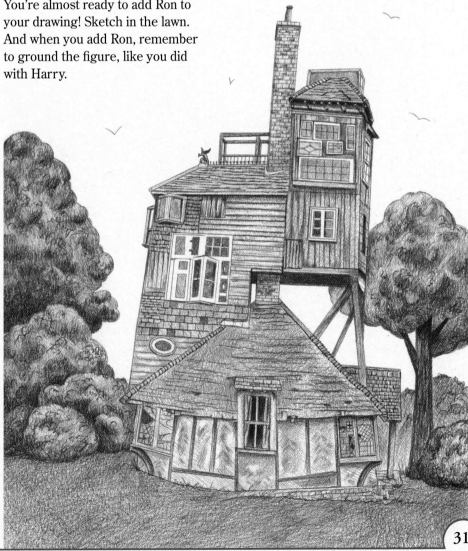

ARTIST'S NOTES

The Burrow is particularly fun to draw because it doesn't follow the rules. After all, how many houses have you seen in real life that look like that? Don't hesitate to exaggerate some of these traits, the angles, the tilting, etc. Let yourself go as you're drawing, and you'll end up with a scene bursting with life.

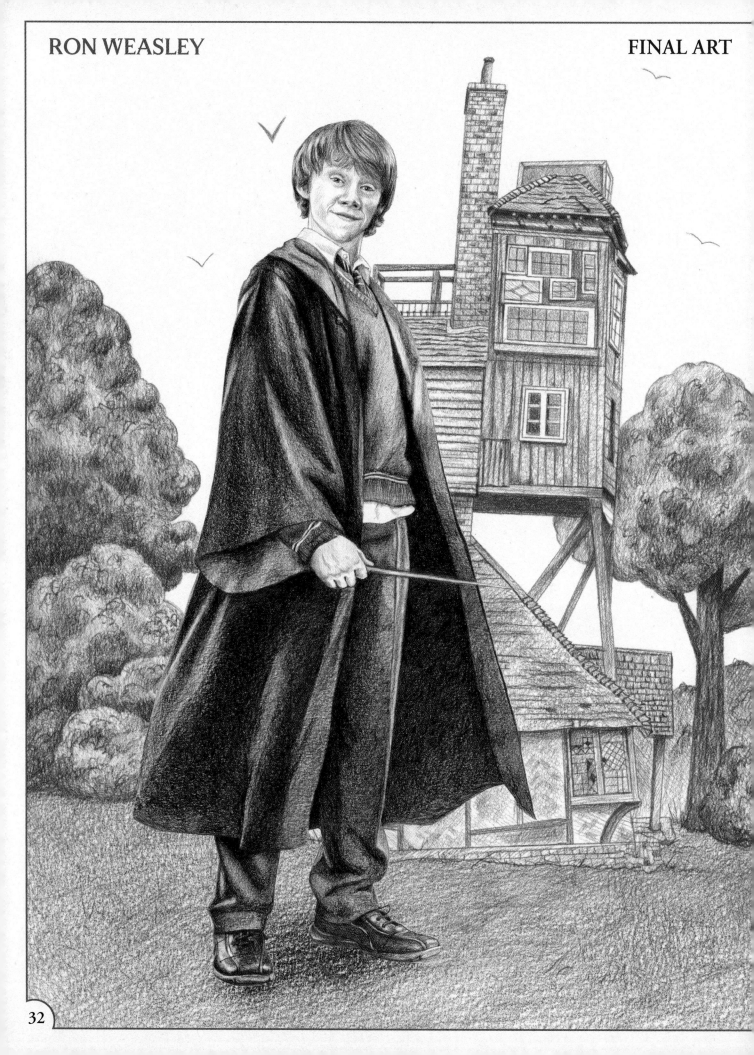

HEDWIG

The Snowy Owl known as Hedwig was given to 11-year-old Harry Potter as a birthday gift by Rubeus Hagrid (the Hogwarts groundskeeper also gave Harry a cake that said, "Happee Birthdae Harry," but that's another story). Hedwig accompanied Harry to Hogwarts in his first year, where she lived with the young student. Like other owls, Hedwig would deliver mail—in this case, letters to and from Harry. Incredibly intelligent, Hedwig proved to be a fiercely loyal and compassionate friend to young Harry as well. During the summers away from Hogwarts, when Harry was forced to once again live with the less-than-magical Dursleys, Hedwig was often his only reminder that there even was a wizarding world.

⭐ Hagrid took it upon himself to purchase Hedwig at a store in Diagon Alley while Harry went to pick out his first very first wand at Ollivander's Wand Shop.

⭐ Hedwig would do anything to protect Harry—she even faced Death Eaters, who had been sent by Lord Voldemort to destroy Harry.

ARTIST'S NOTES

Drawing Hedwig will provide you, as an artist, with an incredible opportunity to broaden your skills. You'll find that drawing an animal is quite different from a human, and it's here that things like photo references will be particularly useful. So you'll want to refer back to this page often as you create your own illustration of Hedwig.

HEDWIG

ROUGH POSE

Just like you did with the human figures, you'll want to start by using a simple stick figure. In this case, use angled lines to indicate Hedwig's wings while drawing a circle in the center where the Snowy Owl's head will be. Delineate the body using a "I" shape, and add the the tail and legs underneath.

CREATING FORM

Over the structure you established in the first step, begin fleshing out Hedwig's outline. Sketch in feathered wing shapes on either side of the character, taking into account the angle of the wings. Draw in the shape of the body, making sure it tapers from the top toward the tail and legs. Last, add the flared-out feathers that will form Hedwig's tail.

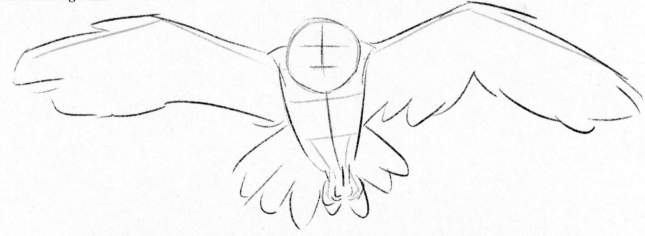

ARTIST'S NOTES

At this stage of the Quidditch match, you want to be focusing on Hedwig's overall shape and making sure you keep everything in proportion to the reference photo. What does that mean? It's a fancy way of saying, "Make sure that you don't draw the wings too big or too small, or Hedwig won't look like Hedwig!"

DETAILED DRAWING

Here's where things start to get really interesting. It's time to transfigure (see what we did there?) the shape of Hedwig's wings from the previous step, and indicate the individual feathers that compose the Snowy Owl's wings. You can use the photograph on page 33 as a guide, but don't worry if you don't capture each and every little feather. As long as the wings are the right size and shape, they'll look fine.

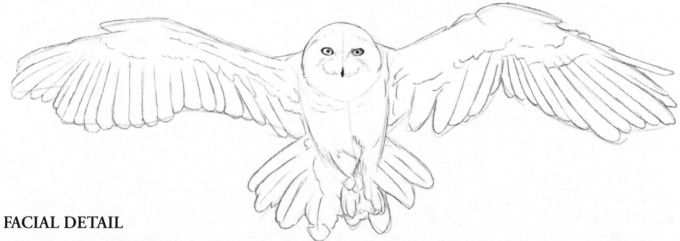

FACIAL DETAIL

Let's turn away from Hedwig's wings and concentrate on her facial features. In the previous step, you indicated the eyes and beak area. But now it's time to really bring out those elements by highlighting them in pencil. You can also add some of the spotted details atop Hedwig's head at this point, and add some shading to areas of the body.

HEDWIG

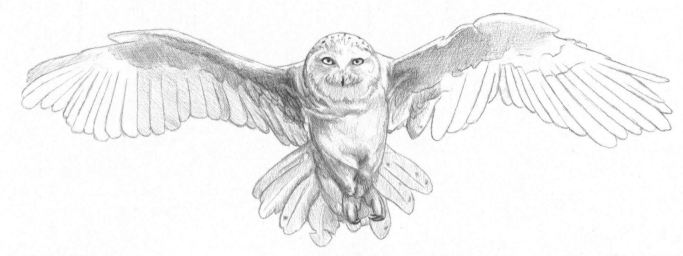

BODY DETAIL

Now you can start to work more on Hedwig's body, adding some shading that shows off the overall shape of the Snowy Owl. It's here that you can really indicate the legs at the bottom, making sure that they're noticeably separate from the tail.

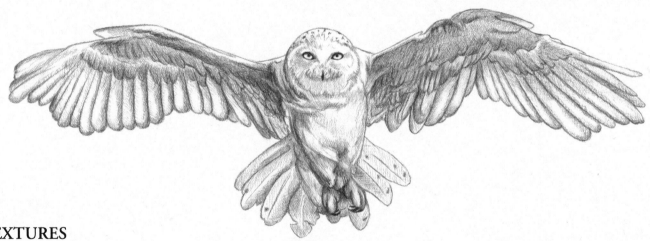

TEXTURES

You've almost completed your first Hedwig drawing—you should notify someone via Owl Post! And, it's time to pay some close attention to the upper section of Hedwig's wings. Instead of one large shaded shape, you'll start adding the little indications of individual feathers that make up those sections of the wings. Note how those feathers are much smaller than the feathers toward the bottom.

BACKGROUND

In choosing a background that befits
Hedwig, we've chosen a moody scene
with Hogwarts in the background
and the Whomping Willow visible in
the foreground.

ROUGH LAYOUT

To begin, you can start sketching in
the background elements where you
think they'll look best around your
figure of Hedwig. Don't feel like you
have to replicate the photo reference
exactly. Like we said before, you're
going for a mood and a feeling, not
for simply reproducing the image.
For example, you can make the
Whomping Willow more prominent
if you want.

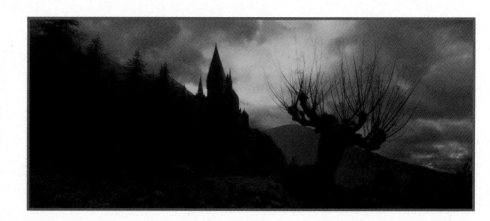

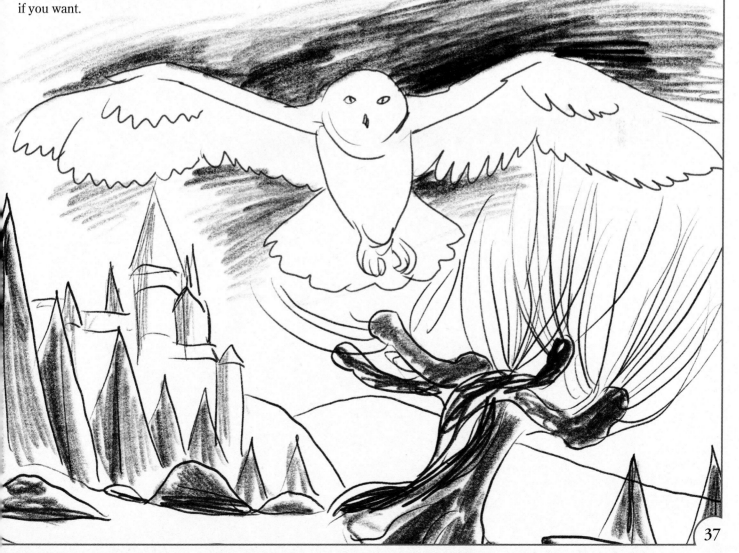

HEDWIG

STRUCTURE

Once you've sketched in the basic shapes of your background, you can start to add some structure to the buildings and surrounding grounds.

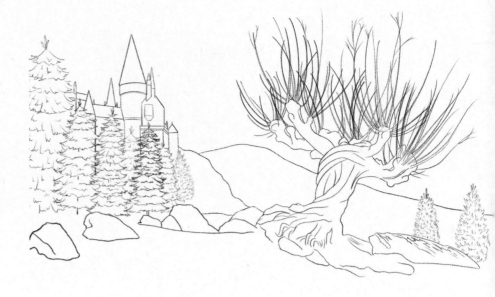

SHADING AND DETAILS

For the group of trees to the left of the background, you can start to add shadows and lines to indicate the various branches. You don't need to draw in every single little pine needle! You just want to communicate the overall look of the trees.

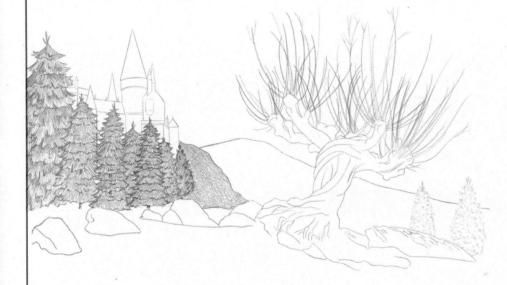

BACKGROUND DETAILS

As you work on Hogwarts in the background, remembering that because the building is farther away in your drawing, fewer details will be visible. Add shading to the ground as well, using shadows to indicate changes in the rocky surfaces.

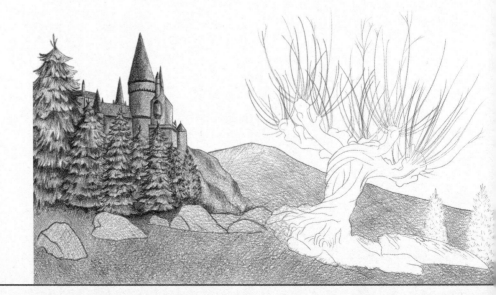

FOREGROUND DETAILS

As you near the end of the drawing, you'll want to focus the areas that are in the foreground, like the Whomping Willow. Since it's closer to someone looking at the drawing, more detail should be visible.

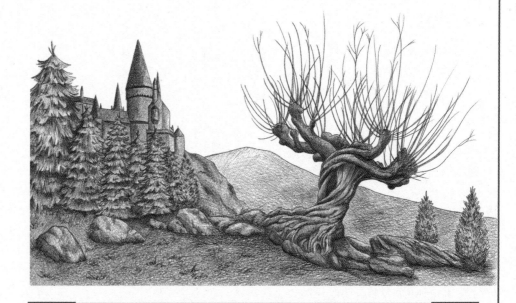

COMPOSITION

We've enlarged the finished drawing so you can take a closer look. While this background would work for any of the human characters, it's particularly perfect for Hedwig, as we see ample sky. Keep that in mind as you place your figure on the illustration.

ARTIST'S NOTES

One of the challenges you'll face with this section is how to make a flying, ungrounded figure like Hedwig stand out from the background. You'll notice that there are lighter areas in the sky that will fall beneath Hedwig when the figure and background are composited. This will help the character pop from the background.

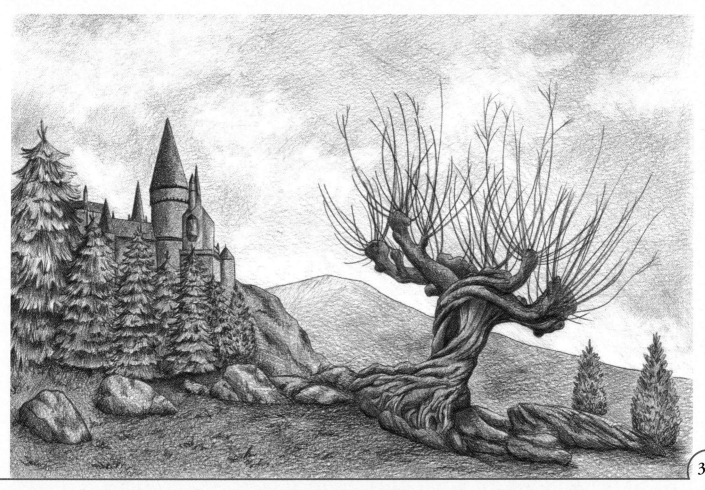

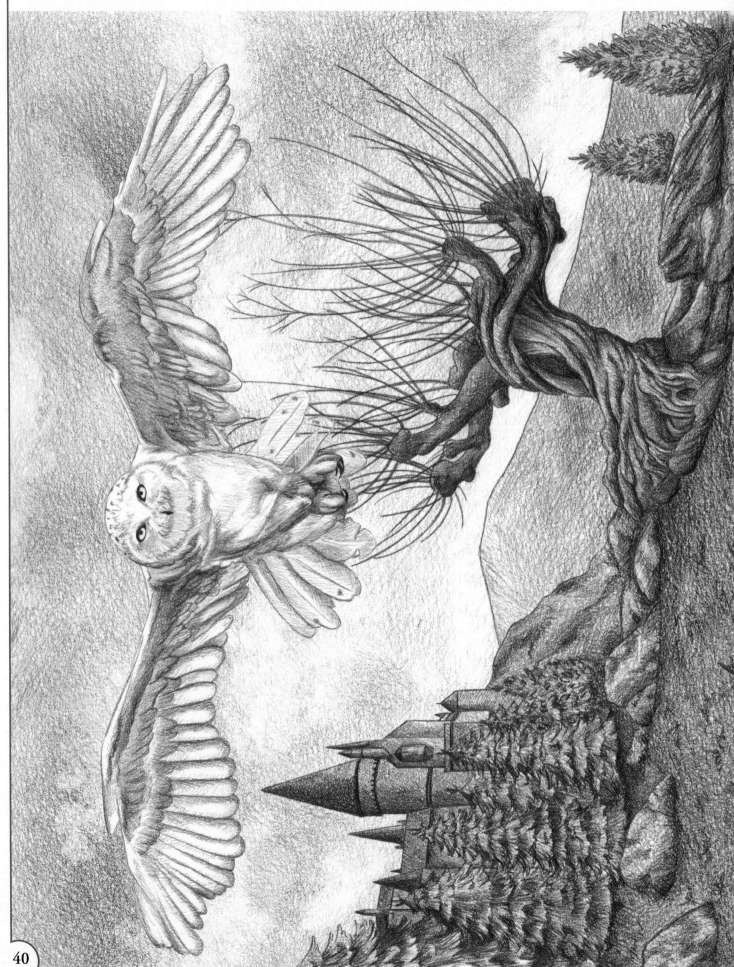

DOBBY

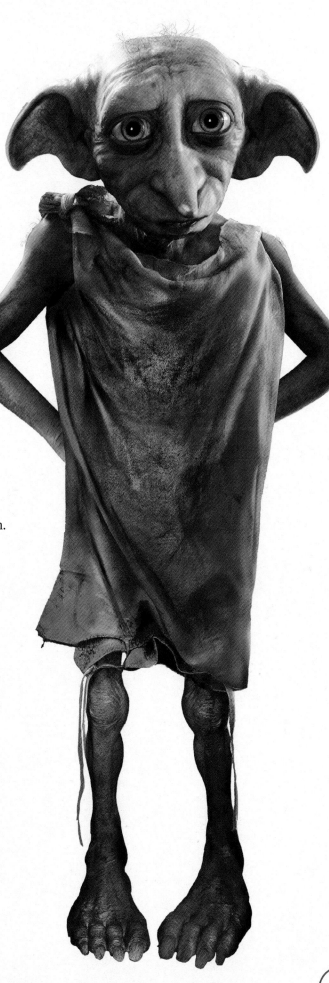

The house-elf called Dobby had been in the employment of the Malfoy family when he first met Harry Potter. The Malfoys were pretty awful to Dobby, but despite this, he managed to remain a decent and kind house-elf. He tried to stop Harry from returning to Hogwarts for his second year, as Dobby believed that danger was waiting there for the young student. Following the opening of the Chamber of Secrets (instigated in no small way by Lucius Malfoy), Harry tricked the elder Malfoy into giving Dobby a sock—the act of which released Dobby from the Malfoys' employment, causing the house-elf to say, "Dobby is free!"

⭐ When the angry Lucius attempted to harm Harry for the sock trick, Dobby protected Harry with a powerful spell, sending Lucius flying. Take *that*, Lucius.

⭐ Captured by Bellatrix Lestrange, Harry and his friends were rescued by Dobby, who gave his life to protect them.

ARTIST'S NOTES

Another fantastical creature, Dobby the house-elf provides an excellent opportunity for you to stretch your creativity. When you look at the photo reference on this page, take note of the shape of the character's ears, nose, and very large eyes. The differences in house-elf and human anatomy will help shape your drawing.

DOBBY

ROUGH POSE

When you begin laying down the framework for Dobby, one of the first things you'll notice is the house-elf's proportions. They're quite different from those of the human characters you've drawn so far. Dobby's head is nearly the same size as his torso. Keep those proportions in mind as you continue.

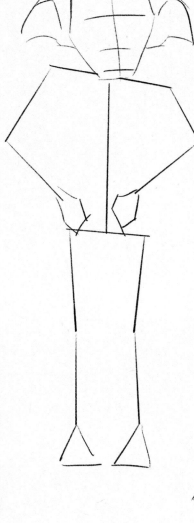

ARTIST'S NOTES

Dobby's mouth falls much lower on his face than it would on any of the human characters, like Hermione or Ron. When you draw the three lines on the face (to indicate eyes, nose, and mouth), remember to keep the mouth line low. Otherwise Dobby's mouth will be where his nose is!

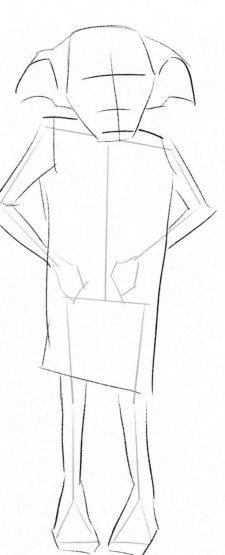

CREATING FORM

As you define the shapes that will make up Dobby's body, there are a couple of things to be aware of. Note that his feet are turned slightly inward—the toes on each foot should be pointing toward the other. And, Dobby can be a bit shy and skittish at times; the position of his shoulders can help convey that attitude.

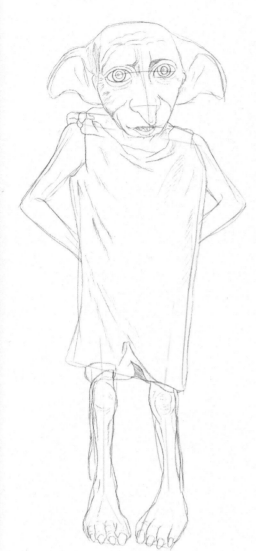

DETAILED DRAWING

Getting into the details with Dobby, one thing to keep in mind is the character's thin, almost frail form. His arms and legs aren't very wide, and the house-elf has what we might call "knobby knees" (which kind of sounds like the name of a Hogwarts wizard). Make sure you don't bulk him up too much, or he won't look like Dobby.

ARTIST'S NOTES

You can use a heavier pencil stroke to create the various wrinkles and folds in Dobby's skin. These folds are evident in Dobby's creased brow, around his eyes, on his cheeks, and on either side of his nose. Use darker strokes and lighter ones to create contrast, which will make the folds appear more prominent where they need to.

FACIAL DETAIL

Dobby's features are very different from anyone else you've drawn so far. From his large, floppy, downward-pointing ears and his large, expressive eyes to his long, pointed nose and shy, friendly grin, Dobby's look says a lot about him. Refer back to the photo on page 41 to help you capture the house-elf's signature look.

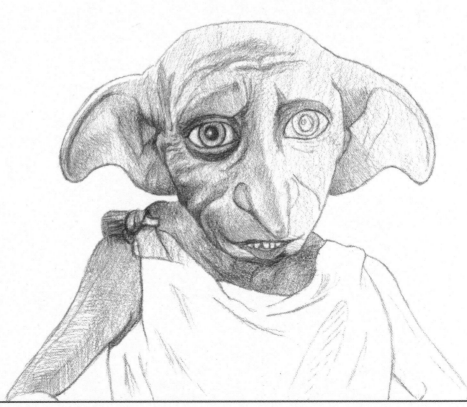

DOBBY

BODY DETAIL

Moving on from the house-elf's face, it's time to work on Dobby's torso and upper arms. As you shade them in, concentrate on making sure that Dobby's modest clothing hangs on his frame loosely. It shouldn't appear to cling to his body, so make sure we can see folds in the fabric.

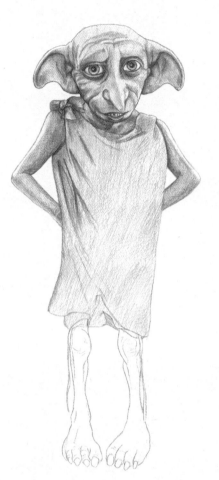

ARTIST'S NOTES

As you're working on the various wrinkles in folds on Dobby's clothes (and this actually goes for his face, as well), make sure you vary the line weights you use by applying more and less pressure with your pencil. The contrast between these two will work some real magic in your illustration and help bring your drawing to life.

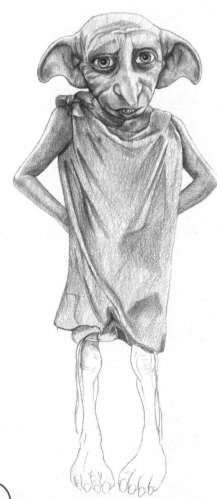

TEXTURES

Moving down the figure, you can add a texture to Dobby's clothes in addition to all the wrinkles and folds. Take a look at the picture on page 41 and get a real sense of what the clothing is made of. Note also that Dobby's clothes are not new—they're quite worn and look dirty, even. You can reflect that in the drawing through darker, cross-hatched patterns on the clothes.

ARTIST'S NOTES

Looking back at the reference for Dobby, you'll see that the character's skin tone, particularly on his arms, is uneven. The coloration is a bit mottled, with light patches and darker ones. This is something you can experiment with in your drawing by making lighter and darker areas that will give your illustration a more realistic edge (yes, realistic, even for a character as fantastic as a house-elf!)

THE FINAL FIGURE

As you finalize your version of Dobby, remember to add the little wrinkles on his knobby knees and to suggest the mottled skin through the use of light and dark areas. Also worth noting are the two strings hanging against Dobby's legs from either side of his clothes. Make sure they don't connect to his legs, otherwise they might look like they're part of his body.

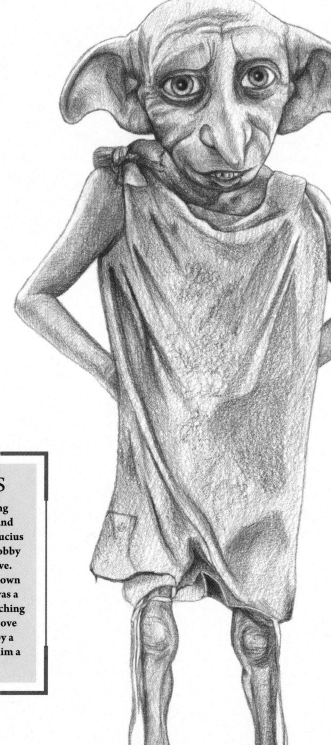

ARTIST'S NOTES

You might want to practice drawing Dobby with different expressions and body language. For example, when Lucius Malfoy attempted to harm Harry, Dobby no longer appeared to be submissive. He stood up to the wizard, using his own magic, and showed Malfoy that he was a house-elf to be reckoned with. Try arching the eyebrows so they angle down above the bridge of the nose to give Dobby a determined expression, and giving him a stern, set jaw instead of a grin.

DOBBY

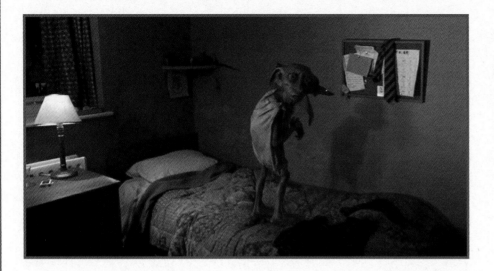

REFERENCE

Since Harry was instrumental in helping Dobby become a free elf, it seems only fitting that we chose Harry's bedroom in the Dursley's home on Privet Drive as the background for the final illustration. While the room itself may appear to be nondescript, it contains a multitude of little details that will be fun to draw.

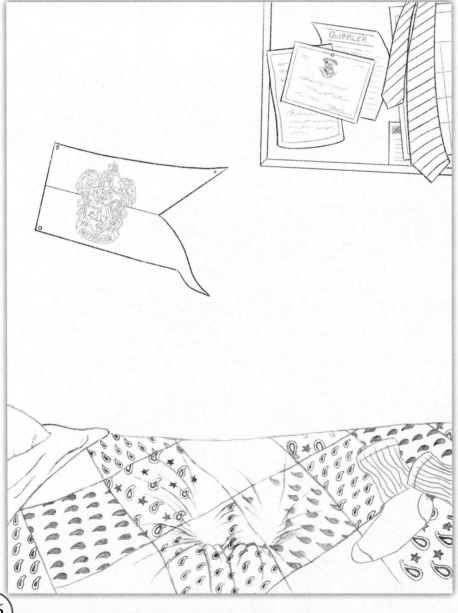

ROUGH LAYOUT

As you select details that you want to include in the background, think about what would make for an entertaining illustration. The bulletin board and various items are full of little details (for example, Harry's school tie, various papers from Hogwarts, a wizarding tabloid called *The Quibbler*). The comforter on Harry's bed also includes several different contrasting patterns. And at this stage, you'll also add two indentations on the bed—this is where Dobby will be standing.

SHADING AND DETAILS

As we noted on the previous page, you'll want to use lighter and medium shades on the background, and save the harsher/darker tones to help set Dobby off from the completed background. As you're adding the details, don't forget to have fun—make sure the socks on Harry's bed stand out (a nice in-joke for anyone who's familiar with Dobby's history).

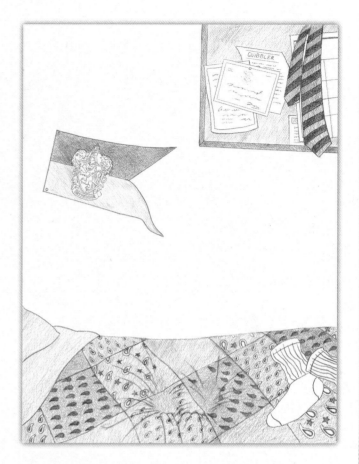

ARTIST'S NOTES

Shading the wall a light gray allows all the cool little details you've drawn to really pop. And once the figure of Dobby is overlayed, and the house-elf becomes the primary focus of the illustration, you'll still notice the neat things going on in the background.

COMPOSITION

When you finally add Dobby to the mix, add a harsh, dark shadow behind the right-hand side of the character on the wall. The shadow will make Dobby stand out from the rest of the illustration.

BUCKBEAK

Buckbeak was a spirited Hippogriff, cared for by Rubeus Hagrid. "Spirited" is a way of saying, "he was kind of wild and you probably shouldn't make any sudden moves around him." A magical creature with the head, front legs, and wings of an enormous eagle, as well as the tail and hind legs of a horse, Buckbeak was introduced to Harry Potter and his fellow students when Hagrid taught the Care of Magical Creatures class. With Hagrid's guidance, Harry approached Buckbeak and mounted the Hippogriff, taking him for an incredible flight. The two formed a bond, and Harry and Hermione even saved Buckbeak when Draco Malfoy's father, Lucius, insisted the Hippogriff be destroyed for injuring his son.

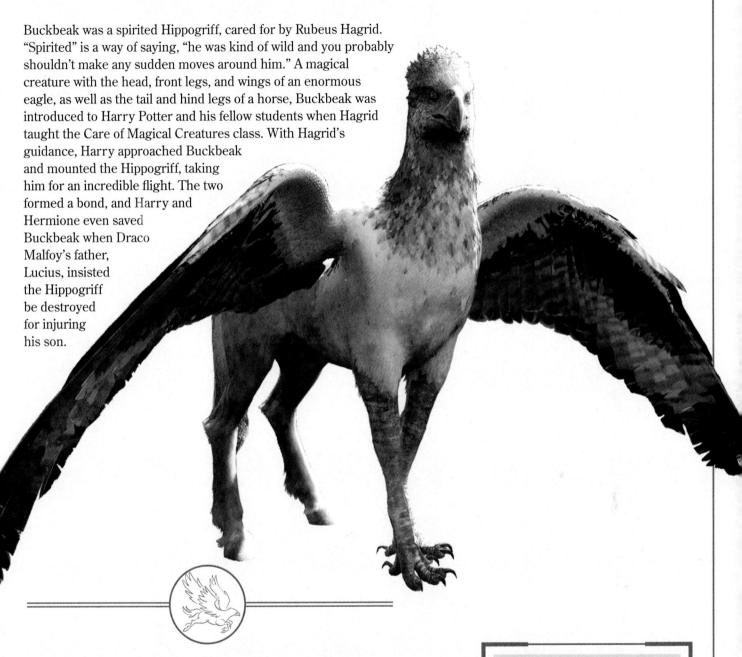

⭐ It's true that Buckbeak *did* knock Draco Malfoy down, but only because the snide student had rapidly approached the Hippogriff despite Hagrid's warning, and called Buckbeak "a great, ugly brute."

⭐ Buckbeak aided Harry and Hermione in freeing Harry's imprisoned godfather, Sirius Black, and helped Sirius evade capture.

ARTIST'S NOTES

You already had some practice drawing wings with Hedwig. You'll get to flex those muscles again with Buckbeak while you try something you haven't done yet—combining different animals to create an entirely new, magical creature.

BUCKBEAK

ROUGH POSE

Just like you did for the human figures, you'll want to begin with a series of circles and lines to indicate Buckbeak's structure. Use larger circles for the head, chest, and hind end and lines to represent the legs, back, and wings.

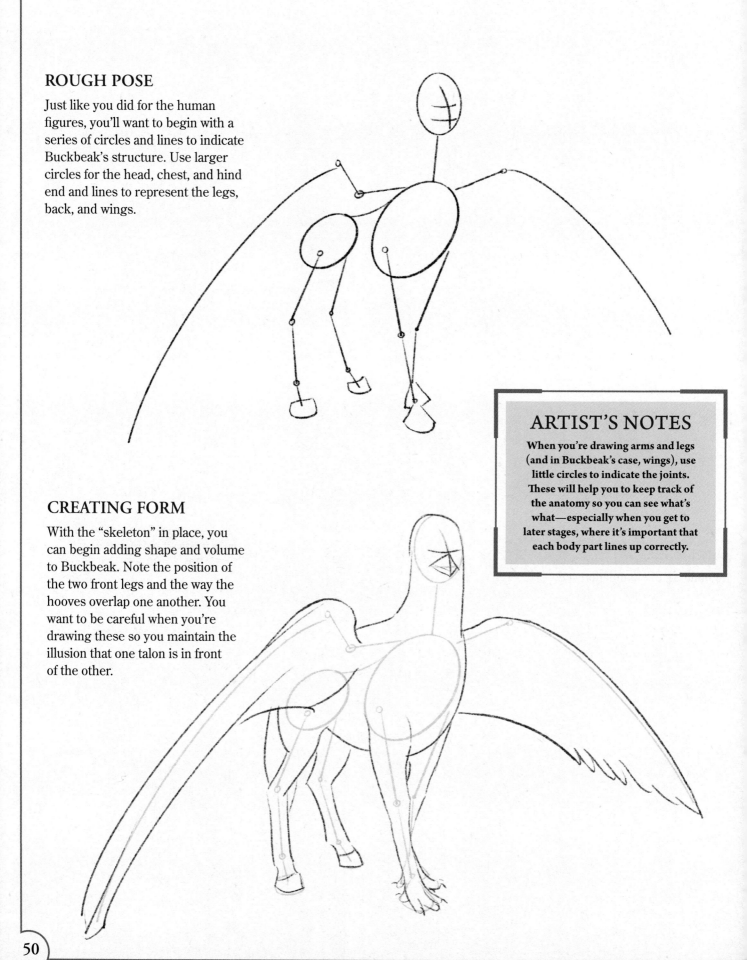

CREATING FORM

With the "skeleton" in place, you can begin adding shape and volume to Buckbeak. Note the position of the two front legs and the way the hooves overlap one another. You want to be careful when you're drawing these so you maintain the illusion that one talon is in front of the other.

ARTIST'S NOTES

When you're drawing arms and legs (and in Buckbeak's case, wings), use little circles to indicate the joints. These will help you to keep track of the anatomy so you can see what's what—especially when you get to later stages, where it's important that each body part lines up correctly.

DETAILED DRAWING

Begin adding details to Buckbeak's body, using the image on page 49 as reference. Like you did with Hedwig, you can draw in larger shapes to indicate the feathers on Buckbeak's wings. You can use smaller strokes to add the feathering around the Hippogriff's neck area and crest as well.

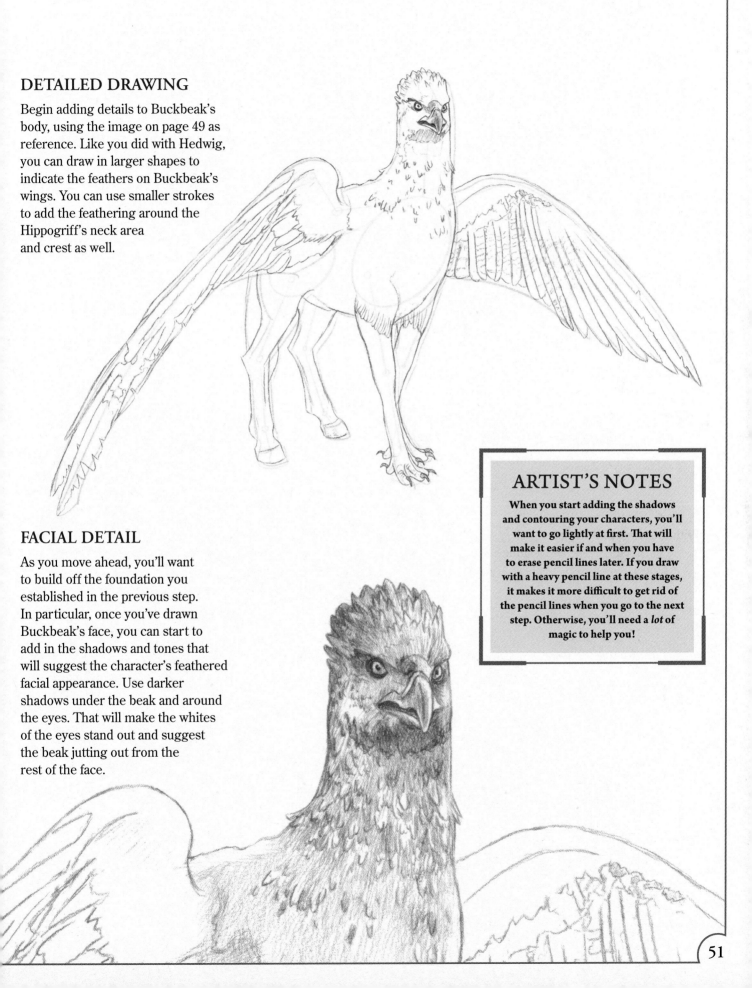

FACIAL DETAIL

As you move ahead, you'll want to build off the foundation you established in the previous step. In particular, once you've drawn Buckbeak's face, you can start to add in the shadows and tones that will suggest the character's feathered facial appearance. Use darker shadows under the beak and around the eyes. That will make the whites of the eyes stand out and suggest the beak jutting out from the rest of the face.

ARTIST'S NOTES

When you start adding the shadows and contouring your characters, you'll want to go lightly at first. That will make it easier if and when you have to erase pencil lines later. If you draw with a heavy pencil line at these stages, it makes it more difficult to get rid of the pencil lines when you go to the next step. Otherwise, you'll need a *lot* of magic to help you!

BUCKBEAK

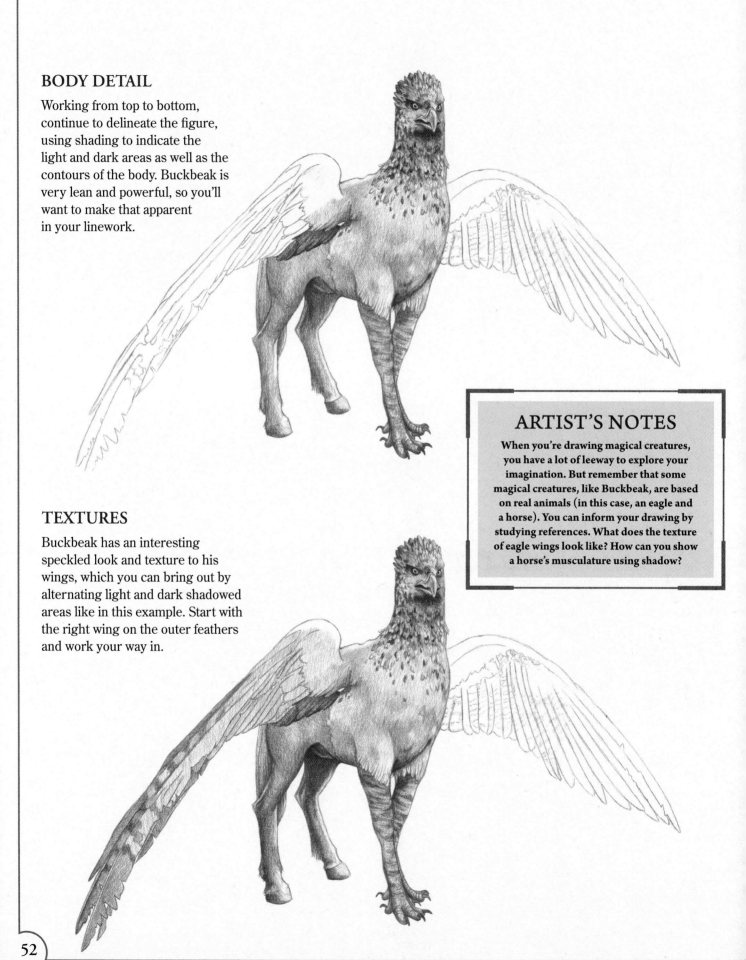

BODY DETAIL

Working from top to bottom, continue to delineate the figure, using shading to indicate the light and dark areas as well as the contours of the body. Buckbeak is very lean and powerful, so you'll want to make that apparent in your linework.

TEXTURES

Buckbeak has an interesting speckled look and texture to his wings, which you can bring out by alternating light and dark shadowed areas like in this example. Start with the right wing on the outer feathers and work your way in.

ARTIST'S NOTES

When you're drawing magical creatures, you have a lot of leeway to explore your imagination. But remember that some magical creatures, like Buckbeak, are based on real animals (in this case, an eagle and a horse). You can inform your drawing by studying references. What does the texture of eagle wings look like? How can you show a horse's musculature using shadow?

ALMOST THERE . . .

Continue to add contrasting areas to Buckbeak's wings using the method you learned in the previous step. Adding a curved shadow to the top of the wing will create the appearance of a ridge. But be careful—if you make that shadow too harsh, it will ruin the effect and make the wing seem like it isn't attached to the body.

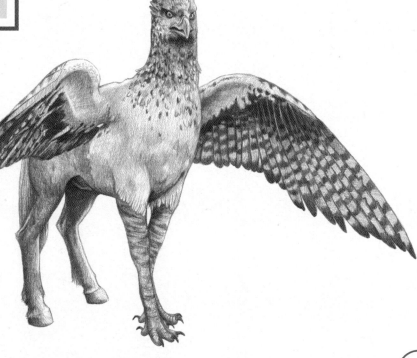

ARTIST'S NOTES

Buckbeak can be a tricky character to illustrate precisely because he's a combination of creatures. Remember that his front half is based on an eagle, while the back is horse. Don't get confused and put eagle claws on the rear legs and hooves on the front ones!

FINAL FIGURE

Once you bring the contrasting shading technique to the left wing, you're just about finished. Go over your figure for any last-minute tweaks that you want to make, and erase any stray lines from previous steps that you no longer need. Congratulations—you've successfully tamed Buckbeak!

BUCKBEAK

REFERENCE

Buckbeak lives out by Hagrid's hut. But when Hagrid teaches his class, he brings Buckbeak to the forest. So in this case, we're providing two reference images—one of Hagrid's hut (with a wide assortment of pumpkins), and one of the forest. As you'll see, we can combine elements from each into one very effective background.

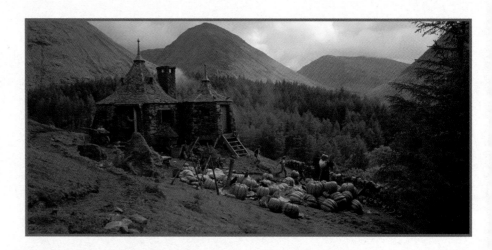

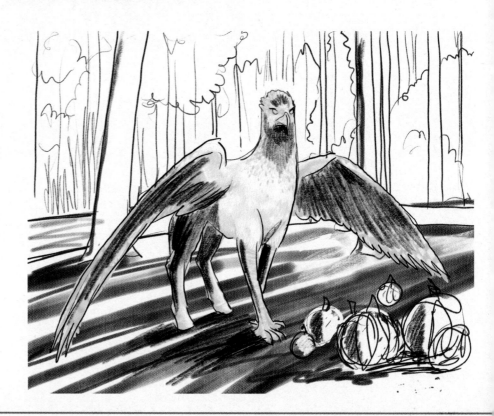

CHOICES

The forest seems like a natural setting for a Hippogriff, so we've chosen that background as our starting place. But the pumpkins provide a rounded shape that will contrast nicely with the straight, vertical trees, so we'll select those for placement in the foreground.

ROUGH LAYOUT

Keeping in mind where you want the figure of Buckbeak to go, begin by putting in the shapes for the background. Make sure you leave room for the character, and that it won't block something important that you want to show later.

SHADING AND DETAILS

This forest background poses a challenge for the artist. With all of the trees come lots of textures, details, and shadows. It's important to handle them just right so you don't overwhelm the figure of Buckbeak once you add it to the drawing. The trick is to suggest detail with your pencil strokes, but not add so much that it becomes the focus of the overall illustration.

ARTIST'S NOTES

You can create the appearance of sunlight breaking through the forest by adding slanted shadowy areas on the ground. Start with one tree, and decide where the sun is coming from. In the case of this illustration, imagine the sun is coming from the right-hand side. The tree trunks block the sun, allowing light to fall on the other areas on the ground. Use a shadow to indicate the position of the trunk on the ground. Repeat for the other trees.

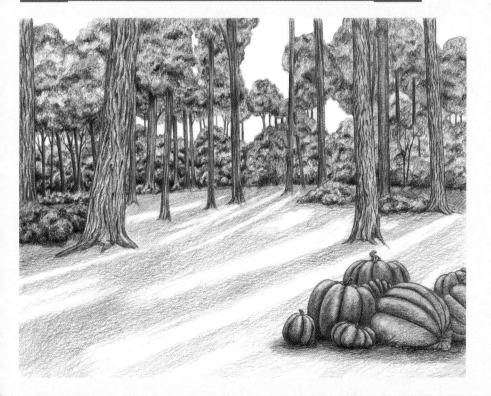

COMPOSITION

With your drawing nearly finished, it's time to put it all together and add Buckbeak to the composition. Remember when you place the figure to add the shadows underneath. Unlike Hedwig, Buckbeak isn't flying in this pose, so you'll want to make sure the Hippogriff is grounded.

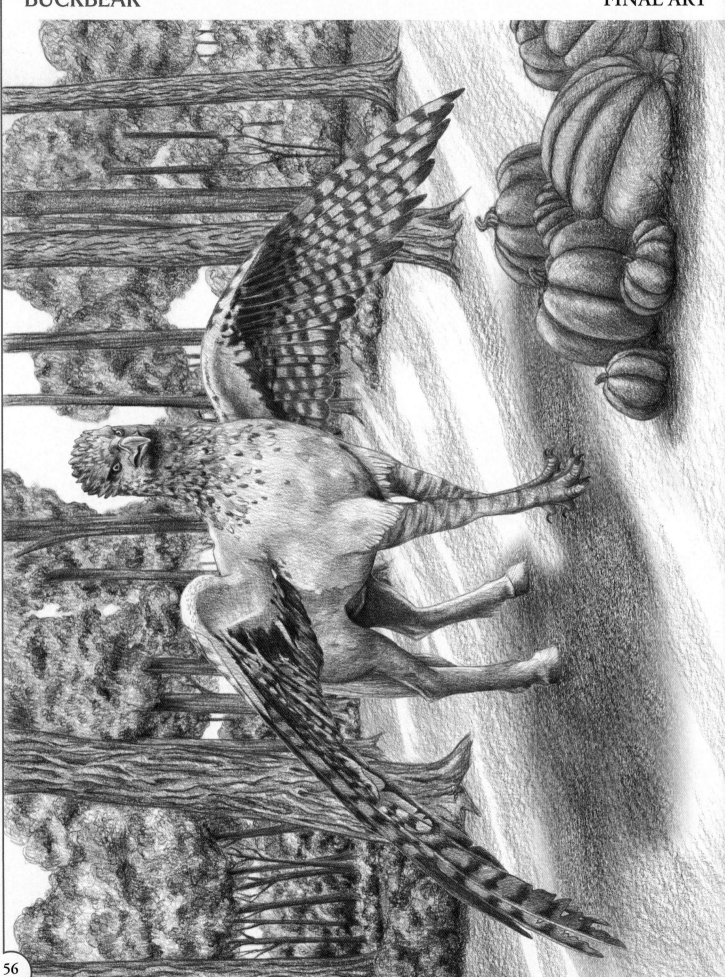

ALBUS DUMBLEDORE

The beloved Headmaster of Hogwarts School of Witchcraft and Wizardry, Albus Dumbledore was incredibly protective of Harry Potter. He, along with Professor Minerva McGonagall and Rubeus Hagrid, was responsible for hiding young Harry from Lord Voldemort after his parents' deaths. Once Harry Potter came of age and attended Hogwarts, Dumbledore kept a close eye on him (as well as his friends, Ron Weasley and Hermione Granger), making sure that no harm came to him. (And there was a lot of harm out there waiting for Harry!) A former Defense Against the Dark Arts professor, Dumbledore was a powerful wizard. But even more powerful was his wisdom and kindness.

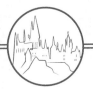

⭐ Dumbledore attended Hogwarts himself—and like Harry, Hermione, and Ron, was sorted into Gryffindor house. The question is, though—did he get into as much *trouble* as the trio?

⭐ Years later, after Harry had married Ginny Weasley, they named their second son Albus Severus Potter, after both Albus Dumbledore and Severus Snape.

ARTIST'S NOTES

When you first behold Albus Dumbledore, one of the first things you'll notice is his long, white hair and flowing beard. In this section, you'll get to work on techniques to illustrate hair, including how light and shadows play off it, and various textures you can create.

ALBUS DUMBLEDORE

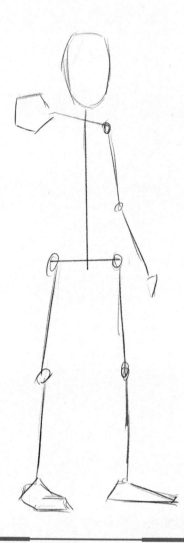

ROUGH POSE

Sketch in the stick-figure framework for this incredible wizard, indicating the head, shoulders, arms and hands, hips, legs and feet. One of the things you'll see right away is that we've drawn Dumbledore's right hand a bit larger than the left. That's because the right hand appears closer to the viewer. This is called forced perspective—you're "forcing" the perspective of your illustration so one things looks closer than another.

ARTIST'S NOTES

When you're drawing in Dumbledore's wand, be careful that you don't make it too long. That's because of the forced perspective. You're creating the illusion that something's closer than something else, and one of the ways that's accomplished is by—gasp!—cheating. While the Hogwarts professors would be aghast at the very idea, cheating here is a good thing. You're "cheating" the angle to make the wand look like it's pointed outward. To accomplish that, you're actually shortening the wand a bit. It sounds weird, but once you practice it a bit, you'll become an absolute wizard.

CREATING FORM

Add form to the stick figure frame by indicating lines for Dumbledore's robes. Sketch in the lines that will indicate his eyes, nose, and mouth, and add in the shape for the wand in his right hand. You'll also want to indicate the hairline and the overall direction and length of Dumbledore's hair. (No need to worry about the beard yet.)

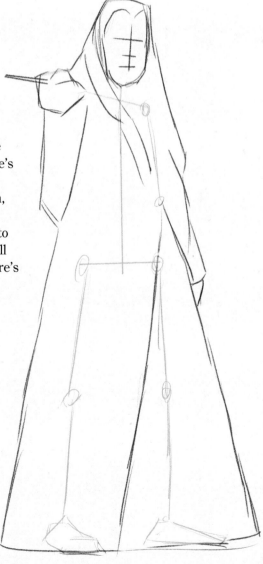

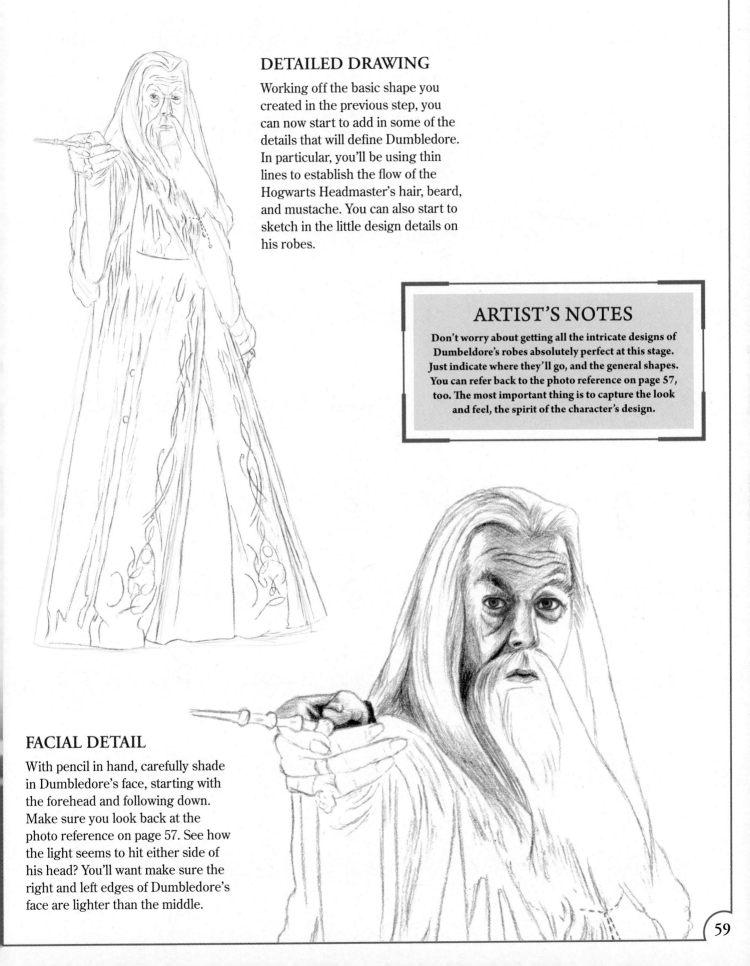

DETAILED DRAWING

Working off the basic shape you created in the previous step, you can now start to add in some of the details that will define Dumbledore. In particular, you'll be using thin lines to establish the flow of the Hogwarts Headmaster's hair, beard, and mustache. You can also start to sketch in the little design details on his robes.

ARTIST'S NOTES

Don't worry about getting all the intricate designs of Dumbeldore's robes absolutely perfect at this stage. Just indicate where they'll go, and the general shapes. You can refer back to the photo reference on page 57, too. The most important thing is to capture the look and feel, the spirit of the character's design.

FACIAL DETAIL

With pencil in hand, carefully shade in Dumbledore's face, starting with the forehead and following down. Make sure you look back at the photo reference on page 57. See how the light seems to hit either side of his head? You'll want make sure the right and left edges of Dumbledore's face are lighter than the middle.

ALBUS DUMBLEDORE

BEARD DETAIL

Continue to define Dumbledore's beard through fine pencil strokes, and remember—since his hair and beard are nice and neat, the pencil strokes should all flow in a similar direction, not against each other (which would look messy).

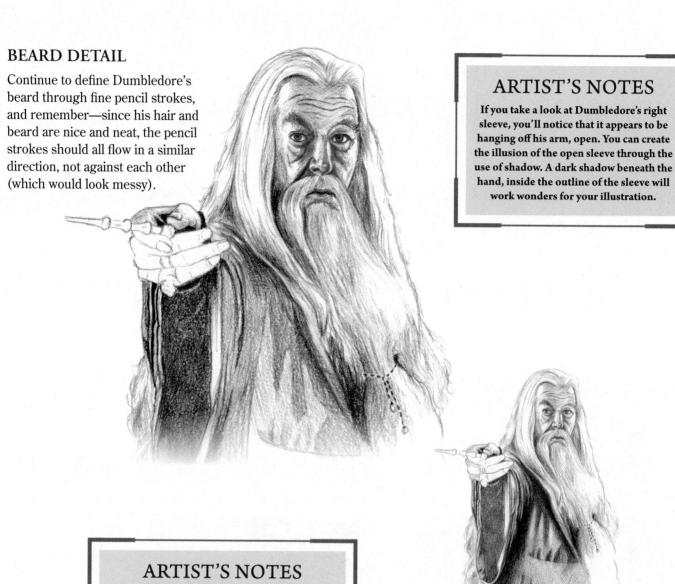

ARTIST'S NOTES

If you take a look at Dumbledore's right sleeve, you'll notice that it appears to be hanging off his arm, open. You can create the illusion of the open sleeve through the use of shadow. A dark shadow beneath the hand, inside the outline of the sleeve will work wonders for your illustration.

ARTIST'S NOTES

In these stages, you can also focus on the rings which Dumbledore wears on his fingers, as well as the unique shape and structure of his wand. These little details will give your drawing an air of authenticity.

TEXTURES

Start to add the texture to Dumbledore's robes with light shading for the flatter parts, and darker shading for the creases, wrinkles, and folds.

ALMOST THERE . . .

Shading from top to bottom, left to right, continue to add the details and shadows to Dumbledore's robes. In this step, you'll want to check the photo reference to complete the pattern that appears on the right and left sides of the robes.

FINAL FIGURE

And with the wave of a wand (or a pencil, in this case), your illustration of Albus Dumbledore is complete! 50 points to Gryffindor! (Or Hufflepuff, Ravenclaw, or Slytherin, depending upon which House you're in.)

ARTIST'S NOTES

You might want to practice the patterns on Dumbledore's robe before you attempt them on the figure. Get a separate sheet of paper and try your hand at forming those lines. It might take some getting used to! Make sure you use a heavier pencil stroke for these lines so the pattern stands out in your final illustration.

ALBUS DUMBLEDORE

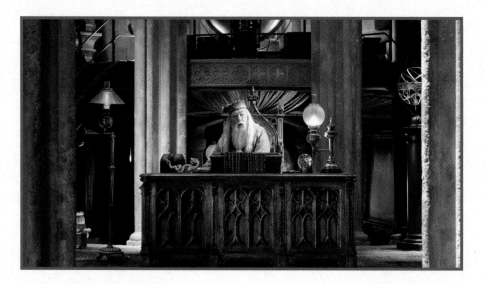

REFERENCE

Dumbledore is right at home in his study, so that seems like the perfect background for the Hogwarts Headmaster. In this setting, you'll find his desk, as well as some interesting elements that will help give your figure of Albus Dumbledore a most magical aura.

ROUGH LAYOUT

As you've done before, use simple shapes to establish the setting. There are lots of details in this one, so make sure you have everything just the way you want it in the sketch before proceeding to the next step.

STRUCTURE

Tighten up your sketch by adding structure. It might help to think of the drawing in layers, beginning with the steps at the bottom, the desk, the chair behind it, and the wall behind the desk and chair.

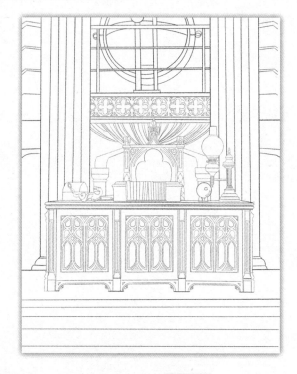

ARTIST'S NOTES

When you're drawing the background, remember that you don't have to try and capture every single little detail from the reference photo. You might want to simplify some things, or eliminate some details altogether. The goal is to make an illustration that you're happy with, and one that will let your final figure of Dumbledore shine.

SHADING AND DETAILS

Start bringing out the details by adding light and dark areas, using the photo on page 62 as reference. You can work from the outside in, keeping the light source in mind.

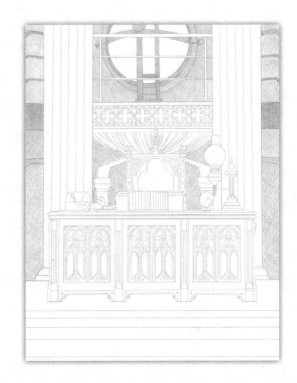

DEPTH

Though the drawing itself is fairly two-dimensional, you're going to create the illusion of depth through clever use of shadows. In this case, placing dark areas behind light ones (like the space behind Dumbledore's desk) will make objects appear to be on different layers.

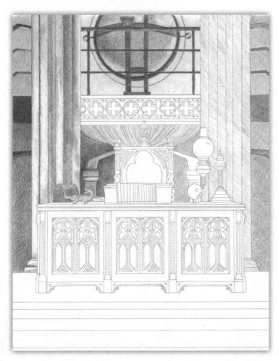

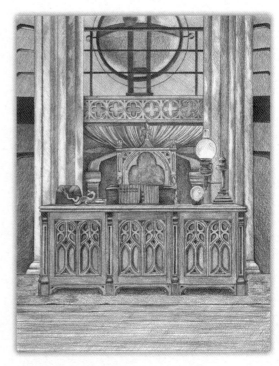

ARTIST'S NOTES

Though you aren't working in color for these illustrations, you'd be surprised at the variety of tones you can achieve through careful use of your pencil. You already know that by pressing down gently, you make very light strokes, or that when you put the pencil point down hard, you make a dark mark. But there's an incredible range of tones in between. Just look at the final drawing on this page—you'll be amazed at all the different shades.

COMPOSITION

Once you're satisfied with your work, you can add your figure of Dumbledore to the composition. Make sure to add a bit of shadow underneath the figure to make it appear like he's really there.

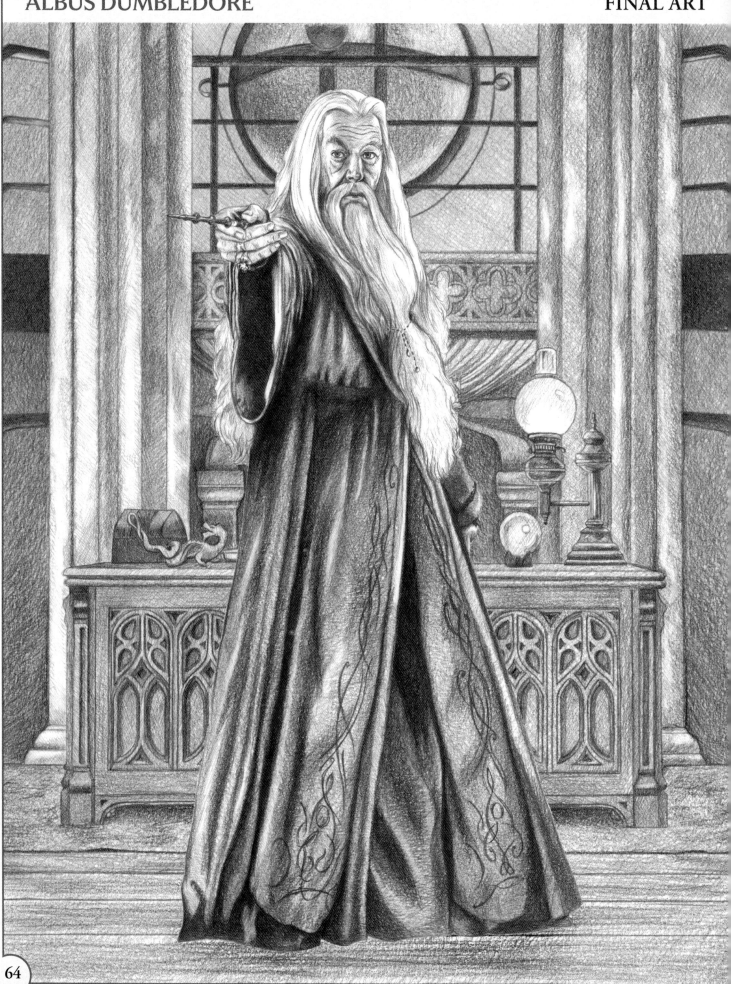

MINERVA McGONAGALL

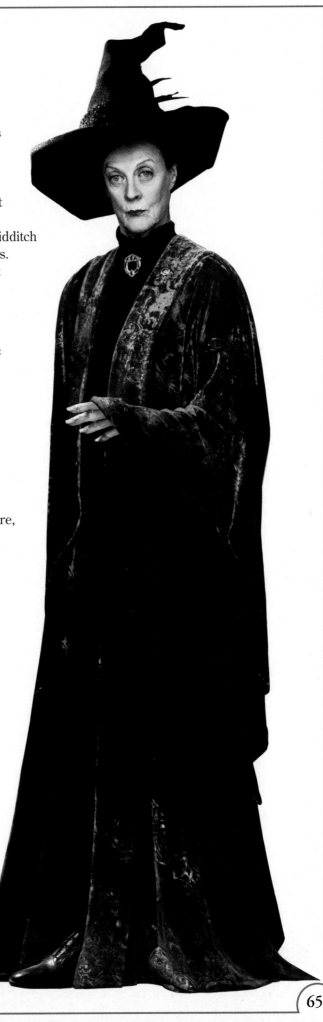

The Deputy Headmistress at Hogwarts, Minerva McGonagall was one of a trio of wizards and witches (with Albus Dumbledore and Rubeus Hagrid) who had protected the infant Harry Potter and delivered him to the care of the Dursley family. When 11-year-old Harry came to Hogwarts, Professor McGonagall began to instruct the young wizard in the art of Transfiguration, her specialty. McGonagall was instrumental in Harry joining the Gryffindor Quidditch team after she witnessed the boy's phenomenal broom-riding skills. Even though she seemed pretty strict, McGonagall had a soft spot for Harry and would often bend rules in his favor.

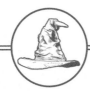

⭐ A prime example of McGonagall bending the rules was when Harry and Ron crashed Mr. Weasley's flying car into the Whomping Willow. Professor Snape suggested the duo be expelled from school, but McGonagall let both students off with detention (and a stern note home!).

⭐ Following the death of beloved Headmaster Albus Dumbledore, Professor McGonagall became Headmistress.

ARTIST'S NOTES

One of the things you'll notice immediately from glancing at Professor McGonagall is her unique wardrobe. The hat in particular is made up of several different shapes and provides the character with a striking silhouette.

MINERVA McGONAGALL

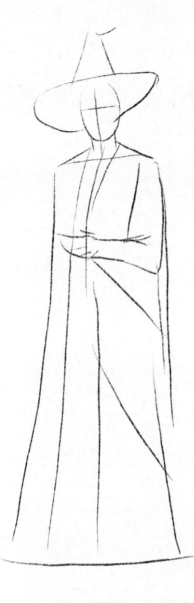

ROUGH POSE

When you work on the rough pose for Professor McGonagall, you'll want to stress a couple of things. First, focus on her hat, making sure that the brim on her right side is wider and more rounded than on her left. Second, note the shape of her robes, and how they flare out slightly toward the bottom.

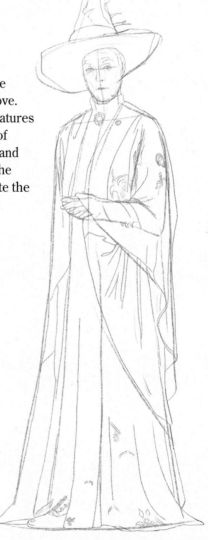

CREATING FORM

In this step, you can build on the framework you constructed above. Indicate the good professor's features (you don't have to go into a lot of detail now—that'll come later), and you can begin to better define the shape of her hat. Start to indicate the various folds and creases in the robes as well.

ARTIST'S NOTES

Drawing characters with hats can present its own set of challenges. It's very easy to focus too much on the hat and not enough on the head—in the end, it will look like your character's head is too small, or cut off, even! (Which is only okay if you're Nearly Headless Nick.) Note how, in the first step, you see the completed oval to indicated Professor McGonagall's head? It's important to establish the anatomy, just like you would with any other figure, *before* adding the hat detail. In other words, form the hat around the head, and not the other way around!

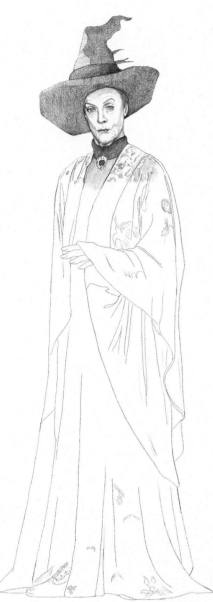

DETAILED DRAWING

Using the top-down method, begin adding the details to your initial pencils that will bring your work to life. Focus on creating light and dark areas that you'll want to accent in later steps, while referring back to the photo reference on page 65. Notice how the shape of the hat—which you initially drew as more rounded at the edges—has changed to become more angular.

ARTIST'S NOTES

Working from a photo reference to try and capture the look of the character, especially their face, takes a lot of practice. So don't be discouraged if, after your first few attempts, the character still doesn't look quite right to you. Keep at it. The more times you draw the same thing, the better you'll get at it. With every new illustration, you'll notice something different, and your lines will become more assured.

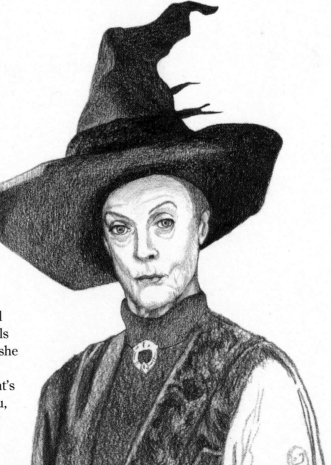

FACIAL DETAIL

As you work on the character's wardrobe, you'll want to also concentrate on the facial features. In this case, Professor McGonagall has arched eyebrows, which reveals something about her character. Is she amused? Not amused? Peeved at a particularly pesky Slytherin student's misbehavior? (We're looking at you, Draco Malfoy.) Try to capture the expression as best you can.

BODY DETAIL

Moving down the body, you'll want to spend some time focusing on Professor McGonagall's left arm and hand. Note how the robes hang, and the folds and shadows it creates. And the character's fingers should be slightly apart (perhaps she's getting ready to cast a spell?) and have a delicate quality to them.

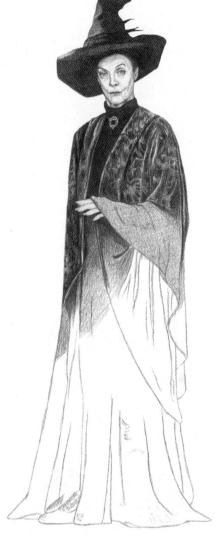

ARTIST'S NOTES

If you're having difficulty drawing hands, you're in fine company. Ask any artist, and they'll tell you that hands can be one of the hardest things to draw! So it's not a bad idea to spend some extra time on the side just drawing hands in different positions. You can look at your own for reference, or ask a friend or family member to model theirs for you!

TEXTURES

If you look at the photo reference on page 65, you can see that Professor McGonagall's robes appear to be made of velvet. Thus, there are darker and lighter areas that suggest that particular texture. You can capture that look as you go through the careful use of shading.

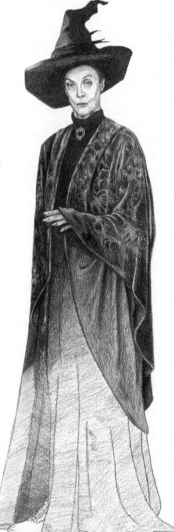

ARTIST'S NOTES

When you're working on adding texture to a character's wardrobe, don't worry about trying to cover large areas all at once. You can start small—for example, in this illustration, work on the edges of Professor McGonagall's robes, starting in one area. Once you have it looking the way you like, move on to the next area, and so on.

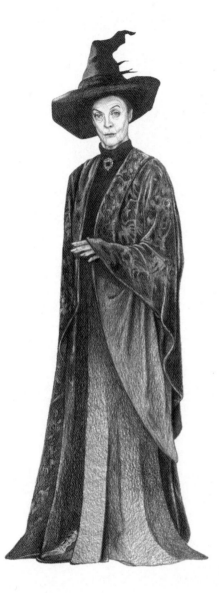

ALMOST THERE . . .

As you near the end of your drawing, it's time to start cleaning up any little bits and bobs that don't quite belong. It's a good thing you have an eraser! And you'll want to continue shading, working on the lower portion of Professor McGonagall's robes.

ARTIST'S NOTES

If you get to the end, and something about the figure still seems off to you, you can absolutely go back and change whatever you want. A drawing is never done until you say it is! Don't hesitate to adjust and revise your work—it's something that all artists do.

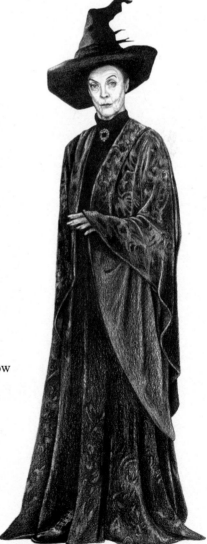

FINAL FIGURE

With a little more added detail to capture the velvet texture of her robes, Professor McGonagall is now complete, and ready to teach her next Transfiguration class!

MINERVA McGONAGALL

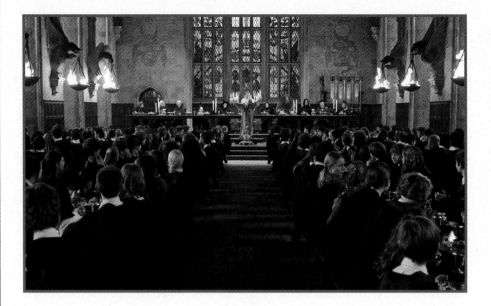

REFERENCE

Is there a more appropriate background for Professor McGonagall than the Great Hall? Since the answer is obviously "no," you can start reviewing this picture to get ideas for the background you're going to draw. Take a moment and observe the layout—the long table in the back, and the (even longer) tables in front.

ARTIST'S NOTES

In this section, you'll utilize something called one-point perspective. What does that mean? Great question! One-point perspective will bring some depth to your drawing. Starting with a horizontal line (in this case, with the table in the rear of the room), draw a dot where all the lines in front (the long tables) will seem to converge. That's called the vanishing point. Draw the lines for each long table angling toward that point. You'll notice immediately, even at the sketch stage, how your drawing appears to have depth!

ROUGH LAYOUT

You know you'll want Professor McGonagall front and center in your final, composited drawing, so sketch a rough of the figure first, then work around her. Using the technique outlined in the Artist's Note above, sketch in the general background shapes.

STRUCTURE

Building off the framework from the previous step, start to construct the basic shapes of the tables, the stone tiles on the floor, and the table, chair, and windows at the back of the room. For this example, don't worry about drawing every single Hogwarts student. We'll cover that next chapter! (Just kidding.)

ARTIST'S NOTES

It can take some practice to get the hang of drawing in one-point perspective, so don't worry if your first attempt looks less than magical. Remember, at some point, everyone was a first year! Just keep on trying, and it will come to you.

SHADING AND DETAILS

As you've done before, think about how the light will hit the different elements of the background, and then shade the light and dark areas accordingly. You can suggest a wood grain to the long tables and benches by using longer pencil strokes.

COMPOSITION

When you put the final figure and your background together, you'll have an amazing illustration of Professor McGonagall in the Great Hall. It's like she's looking right at you! Hope you did your homework, or your House might just lose a few points . . .

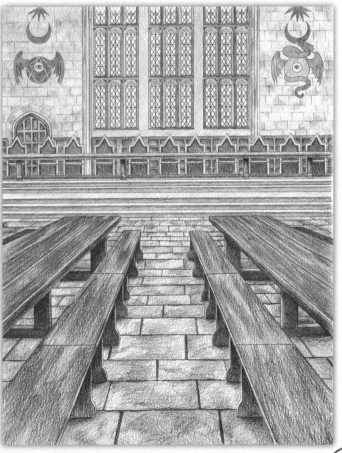

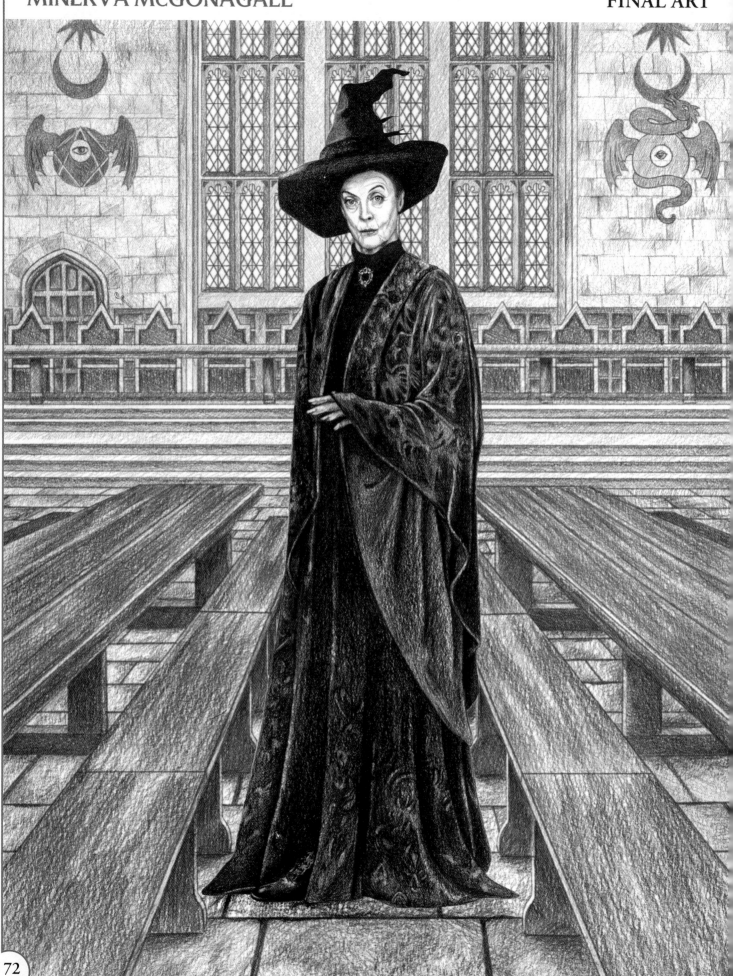

SEVERUS SNAPE

During his career at Hogwarts, Professor Severus Snape was the Potions Master, taught Defense Against the Dark Arts, and, for a brief period, became the Headmaster. Known for his surly disposition and his ability to tame even the most rambunctious students with only a glance, Snape seemed to have a particular dislike of Harry Potter. And by "dislike," we mean, "Snape was kind of mean to Harry, all the time." But the truth was that, in his youth, Snape had fallen in love with Harry's mother, Lily. Following the death of Harry's parents, Snape agreed to help protect Harry under one condition—that Dumbledore never reveal that Snape had feelings for Harry's mother. Harry only learned that Snape wasn't really such a bad guy following the wizard's death.

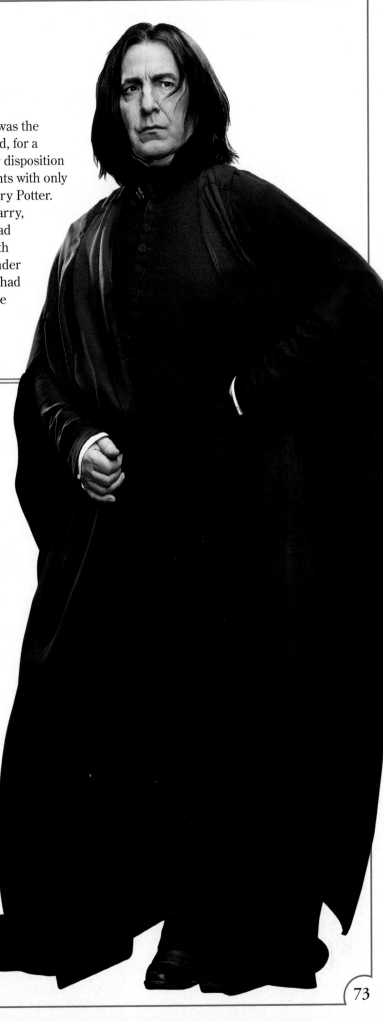

⭐ Before Snape became a professor at Hogwarts, he was a Death Eater—a group of wizards and witches who practiced the Dark Arts and were zealous followers of Lord Voldemort.

⭐ Snape was also the head of Slytherin house and had as his charge Draco Malfoy, the son of Lucius and Narcissa Malfoy.

ARTIST'S NOTES

Snape's personality tends to be a bit dark, and this carries through to his clothing choices. The robes are dark, like those of other Hogwarts professors, but the clothes he wears beneath them also reflect his demeanor. In this section, you'll experiment with using darker tones to convey textures and coloration on clothing, and some intriguing lighting effects as well.

SEVERUS SNAPE

ROUGH POSE

Snape should have a lot of attitude in his pose. See how his right arm is slung slightly lower than his left, and the way the left hand reaches inside the jacket pocket? Practice getting the angle of those arms right as you lay down the stick figure base.

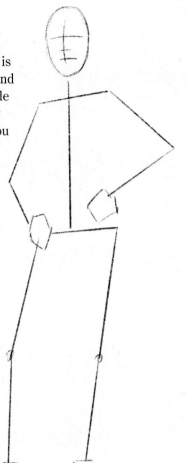

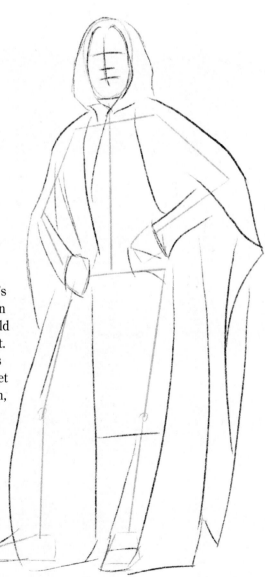

ARTIST'S NOTES

Despite the fact that Snape has a reputation as being a very dark, not-so-nice person, there's still something about him that absolutely commands one's attention and respect. See the way Snape holds himself in this pose? His body language says, "I'm in charge." Experiment with body language in your illustrations. Think about what your character is trying to say—and without saying it, find a way to put that across through drawing.

CREATING FORM

Add the shapes to indicate Snape's dark robes. They're pulled open in the middle, and the left side should be drawn back to reveal his jacket. Using the hand from the previous step, you can add the jacket pocket detail on the character's left. Then, erase the left hand (since that's going to be inside the pocket).

DETAILED DRAWING

With the work of getting the proportions just right and figuring out exactly what's going to go where, you're ready to start adding the details that make Snape so full of spiteful menace. Note the stringy hair that surrounds the character's face, as well as the buttons that appear on the jacket's left side.

ARTIST'S NOTES

There's a tendency to think of Snape as one of the bad guys, even though we know with whom the professor ultimately sided. There's something fun about the characters who aren't so good (we'll talk more about that in the chapter on He-Who-Must-Not-Be-Named). Feel free to experiment with different expressions for Snape, trying to show all the different, not-so-wonderful feelings he might have bottled up inside.

FACIAL DETAIL

Getting Snape's expression down may take a little practice, but it's worth it. The character is full of attitude, and his face communicates that air of dread that surrounds him. Make sure the eyebrows are raised slightly, and the corners of his lips are turned down just a bit in a disdainful look.

SEVERUS SNAPE

BODY DETAIL

Bring out the details in Snape through shading and the careful use of contrast. Differentiate strands of hair by alternating the light and the dark to create the appearance of layers. Try to make each line you draw count—only use exactly what you need to get your point across. Any extra lines can be erased.

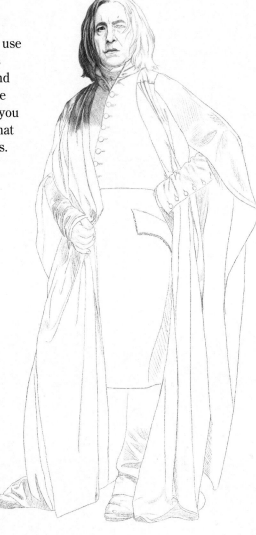

TEXTURES

Create the layered texture of Snape's clothing—the robes, and the jacket/pants underneath by carefully applying shadows. Note how the edge of Snape's jacket with the buttons appears to be raised slightly from the right-hand side.

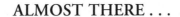

ALMOST THERE . . .

Using the same techniques from the previous steps, continue fleshing out the figure of Snape. Balance the dark areas against the light to create the wrinkles and folds in the clothing, and remember to darken the area behind Snape's left leg to indicate the inside of the robes.

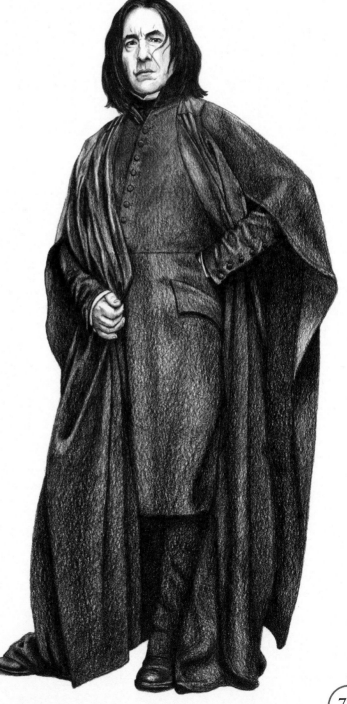

ARTIST'S NOTES

Never forget that as an artist drawing characters, you're responsible for their performance. That's right, their performance! You bring the characters to life in your illustrations, and give them emotions, attitudes, and expressions. And not only expressions—little things like stray hairs falling on a face (as you see in the drawing of Snape) add flare and individuality to your work.

FINAL FIGURE

Go over your drawing for any details you wish to add, and erase any stray pencil lines. It looks like your drawing of Severus Snape is complete! Now tell me, what would you get if you added powdered root of asphodel to an infusion of wormwood?

SEVERUS SNAPE

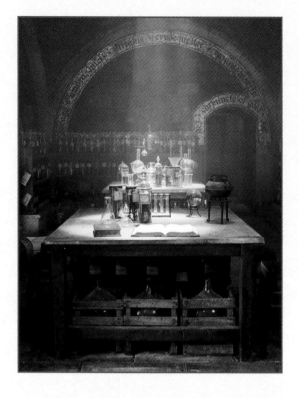

REFERENCE

As you know, Professor Snape was once the Potions Master at Hogwarts. So that would certainly be an appropriate setting for this sly Slytherin. Take a look at the photo reference to the left, and notice all of the details. In particular, pay attention to the shaft of light beaming down into the center. More on that later.

ROUGH LAYOUT

Picking and choosing the details you wish to include in your background, lightly sketch in the various shapes. This background is similar to the one you drew for Dumbledore on pages 62–65, in that you're building up the scene with layers—in this case, the floor, the desk/table with potions, the shelves of potions behind that, and the wall.

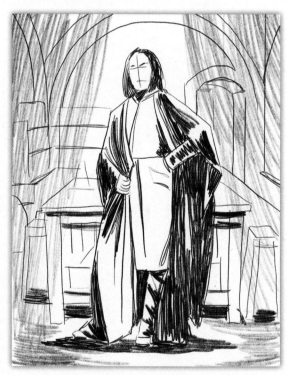

STRUCTURE

As you firm up the rough sketch from the previous step, it's probably a good time to mention that you'll be using one-point perspective again! In this case, imagine there's a dot in the middle of the drawing, about one-third of the way down. All the lines will converge on that one dot.

ARTIST'S NOTES

This background utilizes many different shapes, from the tiles on the floor, to the table, to the rows of potions behind, to the arches on the walls. Each piece needs to fit in, so make sure you spend a little extra time at this stage to get all the details right. It's easier to fix things now than try to revise them when your drawing is at a more complete stage.

SHADING AND DETAILS

Start at the top of the background, and begin to add the shading effects that will separate the bricks on the walls from the stones in the archways.

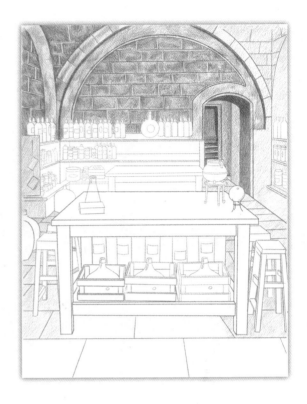

BACKGROUND DETAILS

See all the little potion bottles in the background? You can draw the indications of labels on each (after all, a Potions Master would probably want to know exactly which potion ingredient is which). But don't make them too detailed. Remember that things in the background are farther away and might not be as easy to see or read as things closer to the viewer.

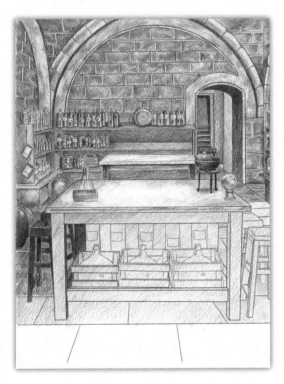

COMPOSITION

Now that you've finished the background, you can composite your figure onto it. To achieve the harsh lighting effect (the light beaming down on Snape from above), you can darken the shadows on the left and right side in a trapezoidal shape, wider at the bottom than at the top.

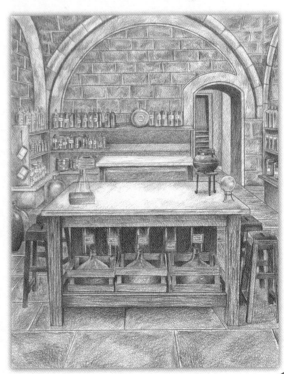

ARTIST'S NOTES

It's especially important to remember to plan for where your figure will be when you have a dark background. You don't want to get stuck erasing a lot to make space.

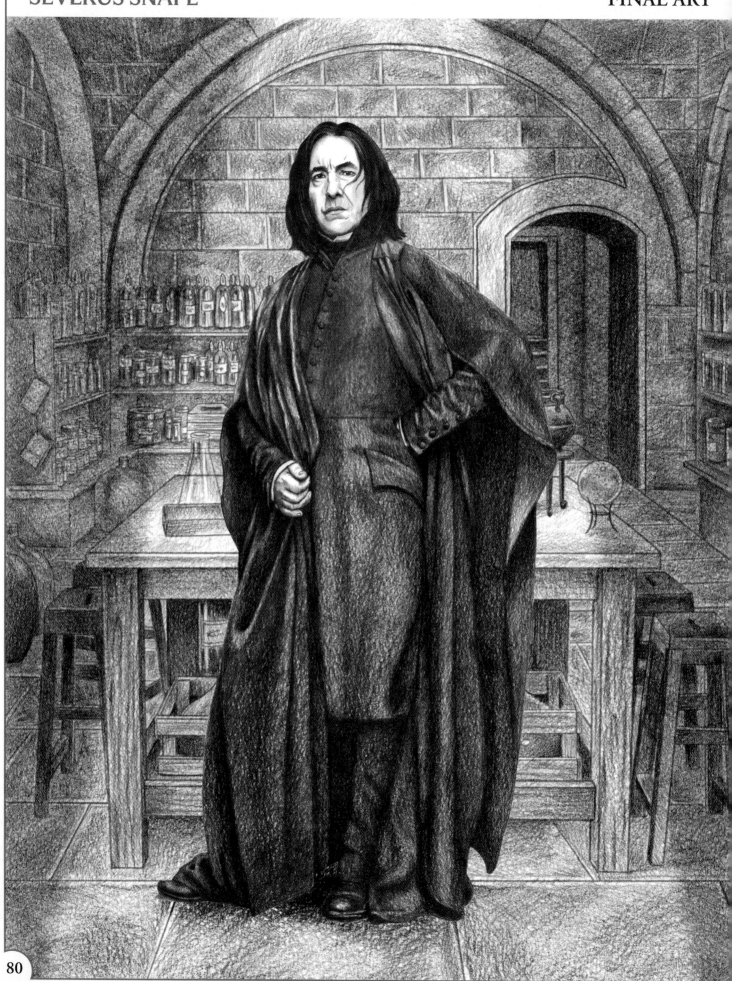

LORD VOLDEMORT

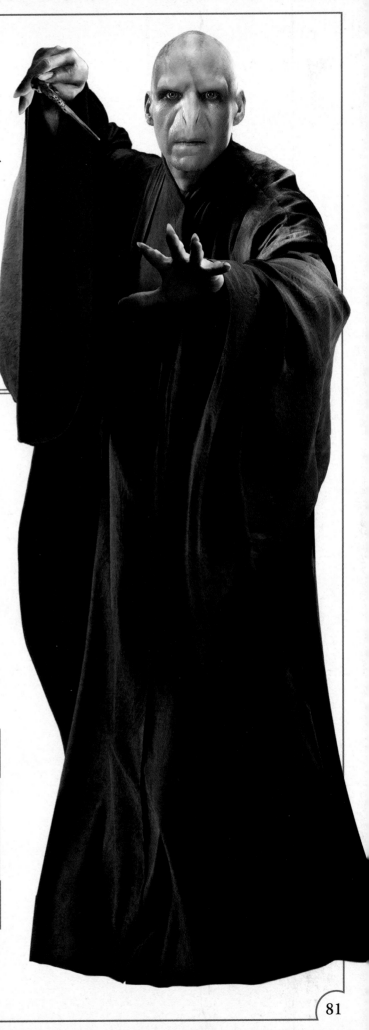

He's gone by many names. Tom Marvolo Riddle. The Dark Lord. He Who Must Not Be Named. You-Know-Who. But we know him, for better or worse, as the infamous Lord Voldemort. Once a promising Slytherin student at Hogwarts, Tom was obsessed with becoming the greatest wizard in the history of magic. Unfortunately, Tom was also obsessed with being evil. He reinvented himself as Voldemort, and attempted to destroy the infant Harry Potter, because Voldemort believed the boy would one day destroy *him*! When the plan failed, Voldemort went into hiding for years, only resurfacing once Harry was old enough to attend Hogwarts.

⊛ Tom Riddle opened the Chamber of Secrets while he was a student at Hogwarts—a forbidden act for which Riddle framed Rubeus Hagrid and his pet Acromantula, Aragog. (How many house points do you think he should have lost for *that*?!?)

⊛ Voldemort split his soul into seven pieces, called Horcruxes. By doing so, he would achieve immortality. But unknown to him, Voldemort accidentally created an eighth Horcrux—Harry Potter himself—when he attempted to destroy the infant. This would ultimately lead to the Dark Lord's downfall.

ARTIST'S NOTES

Voldemort is a totally different type of character than you've drawn elsewhere in this book. Not just because he's completely, totally evil. He's almost human looking, but the details are just off enough that he becomes quite disturbing to look at. His snake-like face (with slits on either side instead of a nose), thin, red lips, and long, pointed fingernails make Voldemort appear otherworldly. Keep that otherworldliness in mind as you approach your drawing.

LORD VOLDEMORT

ROUGH POSE

Voldemort's every move is sinister. Even the way he holds himself is full of menace. When you're drawing the stick figure in this step, you can establish the character's creepy nature by keeping the shoulders raised close the head. The right hand should be raised, as Voldemort will be holding a wand, just about to strike.

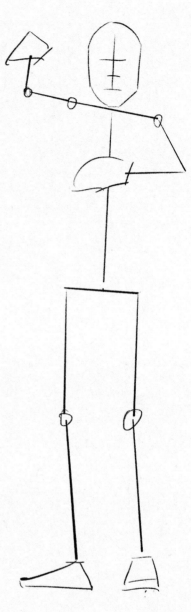

CREATING FORM

We used the word "snake-like" to describe Voldemort's face before, but that term applies to his body as well. When you're blocking in the shapes, think in terms of curves, like a snake. See how the robes flow around him? There are no straight lines.

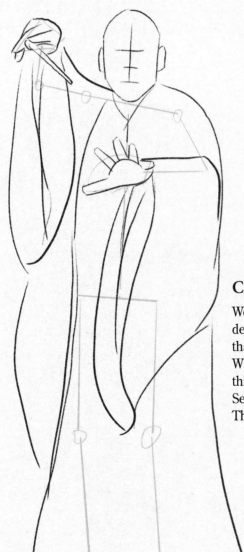

ARTIST'S NOTES

Just because Voldemort doesn't have a proper nose doesn't mean that you won't still draw a line indicating its position on his face. You'll still need to use that line as a guide for adding the two reptilian breathing holes on either side in the coming steps.

DETAILED DRAWING

Conjure some truly disturbing details with your pencil, and work out where the folds and wrinkles in Voldemort's robes will be. You can also rough in the character's face, including those two breathing holes we mentioned in the previous Artist's Notes.

ARTIST'S NOTES

Voldemort's gnarled wand should be pointed downward and to the right (our right, his left). Notice how he holds the wand almost gingerly? Voldemort relishes the evil that he does, and the horrors he conjures with the spells he casts. Think of him as an artist of awfulness—and the wand is his brush.

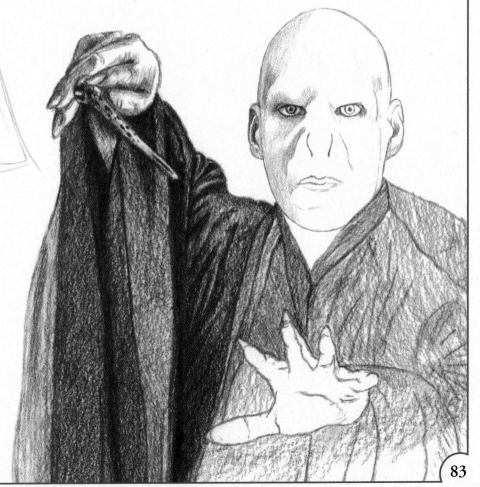

FACIAL DETAIL

Make Voldemort's brow more prominent by adding shadows. This will appear to make the Dark Lord's eyes sit farther back in his skull and create an ominous appearance. Heavy shadows under the eyes will also highlight their evil glint.

LORD VOLDEMORT

BODY DETAIL

Voldemort's robes are quite dark, setting off his very pale skin. So you'll want to make sure the areas behind his left hand are especially dark in order to make the creepy fingers pop out at the viewer.

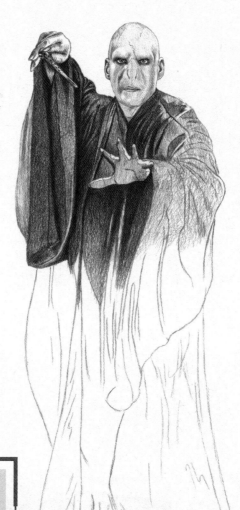

ARTIST'S NOTES

The Dark Lord's robes should hang quite loosely, not clinging to his body. In fact, there's almost no sense of the character's physical body inside the robes. This makes Voldemort seem even more inhuman and will help create a most monstrous look.

ARTIST'S NOTES

Don't forget to put a piece of paper under your hand when you're shading Voldemort's robes. We talked about this before, but it bears repeating here, especially because Voldemort's robes require so much shading. There's the potential to make a huge mess—of both your drawing and your hand—so be careful!

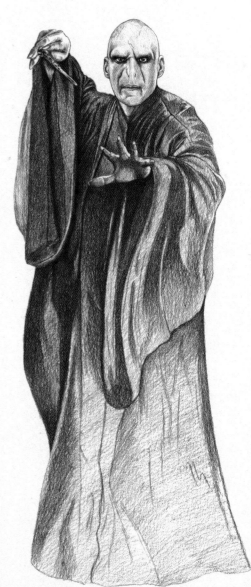

TEXTURES

Unlike some of the other characters you've worked on, Voldemort's wardrobe is quite simple and lacking in detail. This helps direct attention to He Who Must Not Be Named's frightening face. Focus on heavy, dark strokes to create the texture of the robe.

FINAL FIGURE

With some finishing touches, addition of some shadows where you think appropriate, and a little more attention paid to Voldemort's terrifying appearance, you'll be set. Now we suggest you run!

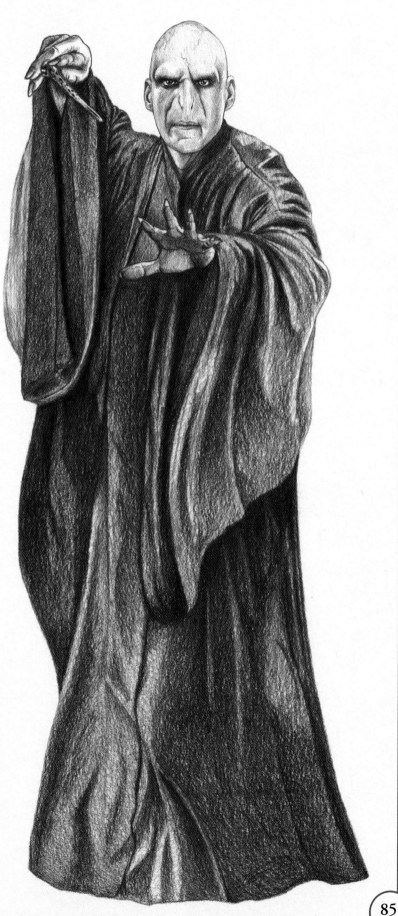

ARTIST'S NOTES

Make sure the shadows under the long, drooping sleeve (his right) are heavy enough to make the shape of the sleeve visible. Otherwise you won't get a sense of the arm shape, and it will look like Voldemort's left hand is coming out from the middle of his chest!

NEXT STEPS

There must be a particularly creepy setting for the Dark Lord. Dare you turn the page and find out what it is?

LORD VOLDEMORT

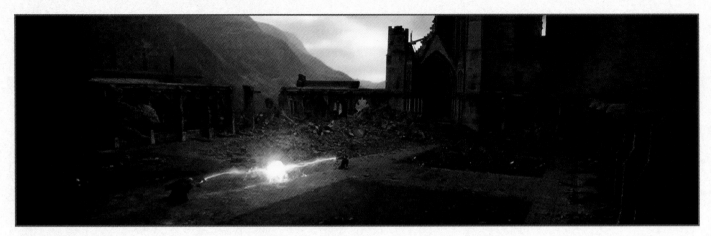

REFERENCE

Because we can't just let the forces of darkness win, we chose the setting of Hogwarts — or rather, the ruins of Hogwarts, during Harry Potter's final battle with Voldemort. Once Harry and his friends destroyed all the Dark Lord's Horcruxes, Harry was able to defeat the master of evil. Maybe that knowledge will make this picture a little easier to draw!

ROUGH LAYOUT

Block in the general shapes for the background, working around a quick sketch of the figure so you have a sense of where things should be placed.

FOREGROUND DETAILS

In this particular drawing, we're placing some details up front—namely, the rubble you see. This will help bring the final figure into the environment.

ARTIST'S NOTES

Take a look at the background illustration. See the way the mountains appear on the left, and slope downward to the middle? And the way the ruins of Hogwarts rise up from the middle, growing bigger toward the right-hand side of the image? This helps direct the eye toward the middle of the drawing and balance out both sides of the illustration.

SHADING AND DETAILS

Shading in the background from the lefthand side, remember that the mountains should recede into the distance—they aren't the focus. So don't put in too many details, or they'll begin to overwhelm.

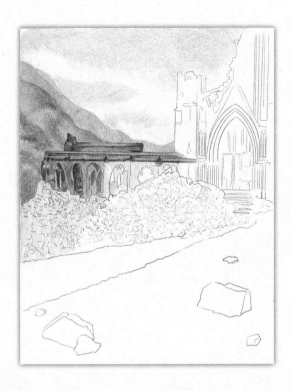

WORKING FORWARD

Think of this particular background as three separate illustrations laid on top of one another: The background layer contains the mountains and the Hogwarts ruins. The middle layer features the rubble. And the foreground layer contains the ground and the rocks in front.

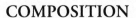

COMPOSITION

Now that you're just about done, you can add your completed illustration of Lord Voldemort to the mix. (We know you're not supposed to call him by his name, but we just couldn't help ourselves.)

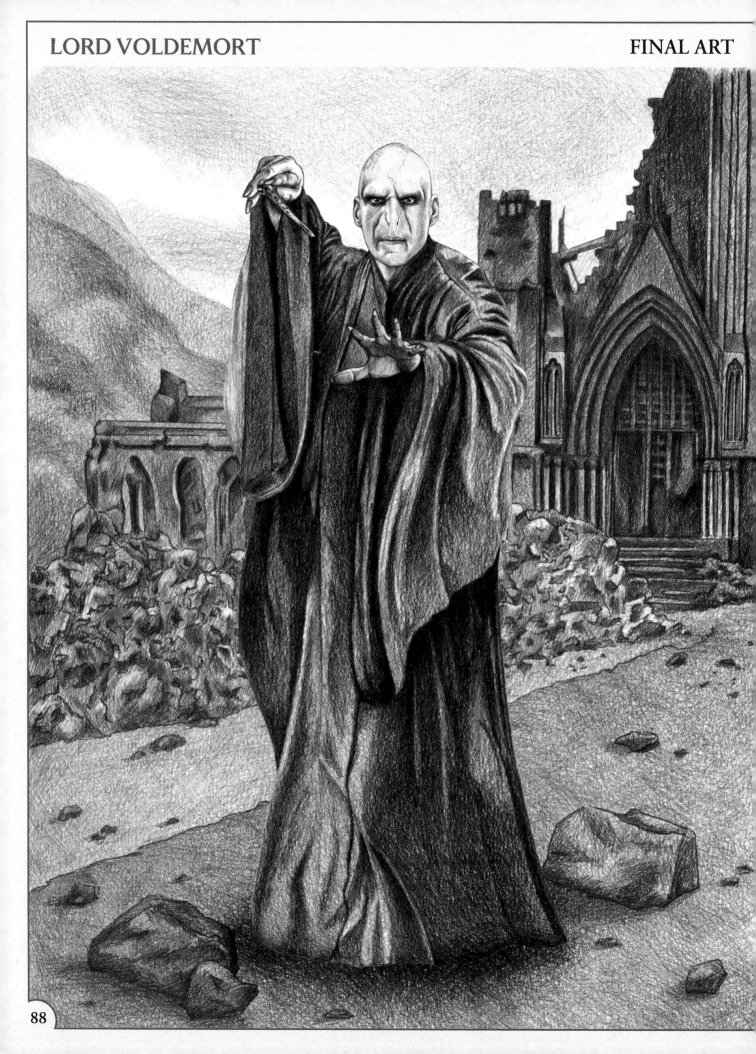

GROUP SCENE

REFERENCE

Taking everything you've learned so far, let's create a group scene. First let's choose a background. In order to feature the characters prominently, we'll need a bit of a wide-open expanse. So we've selected a field with Hogwarts in the background.

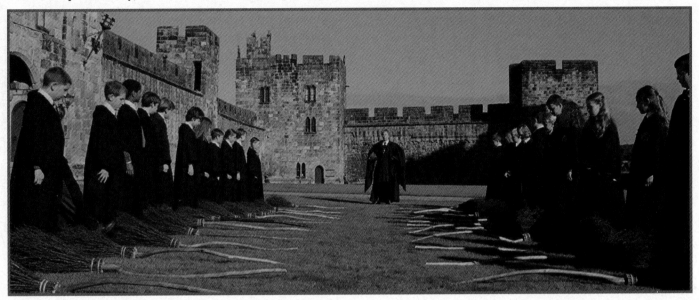

ROUGH SKETCH

Place shapes in the background to indicate the Hogwarts walls and turrets. Then sketch in the characters you want to feature on top. In this case, it's Hermione, Hedwig, Harry, and Ron, with Professor McGonagall, Headmaster Dumbledore, and Professor Snape to the right. And looming over them like a specter is Lord Voldemort. Something to keep in mind as you work—it's okay to make changes to the poses when making a group shot so that everything makes sense. In this illustration, we've adjusted Dumbledore's wand so it doesn't look like he's attacking Harry and his friends. And Voldemort's eyes have been tweaked so his pupils are staring at Harry.

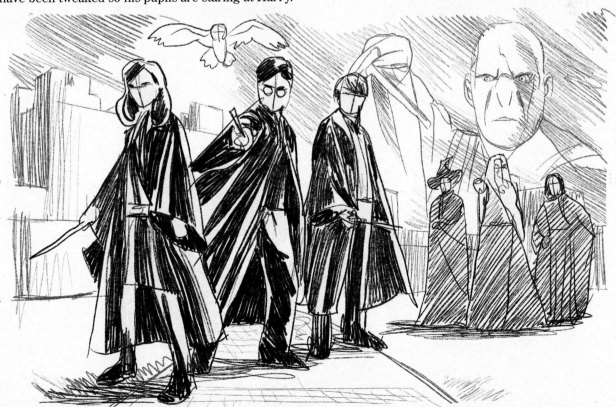

GROUP SCENE

STRUCTURE

Using the techniques you've been practicing, firm up the shape of the walls and buildings. For this background, you'll also want to create a cobblestone path leading from the foreground into an opening in the wall in the background. This path should be wider in the front (as it appears closer) and smaller in the back.

SHADING AND DETAIL

Once you have the background the way you like it, you can start to shade the drawing to create textures and add some dimension to your illustration. Darken in window openings to create a bit of depth, and add some shadows to the left-hand side of the opening in the wall to make it appear lighter at the entrance.

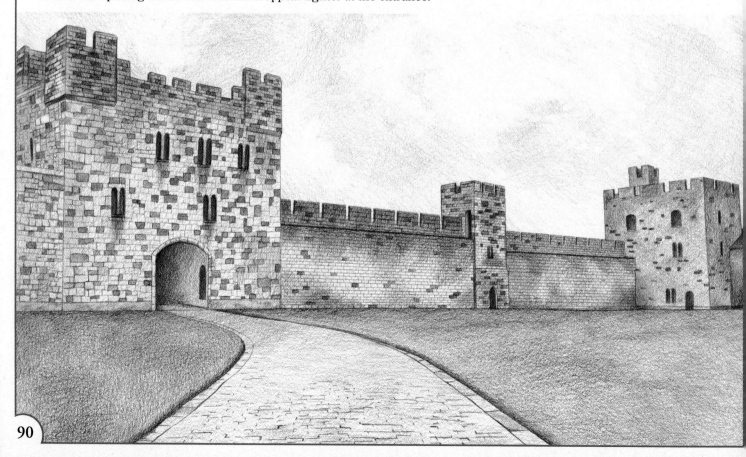

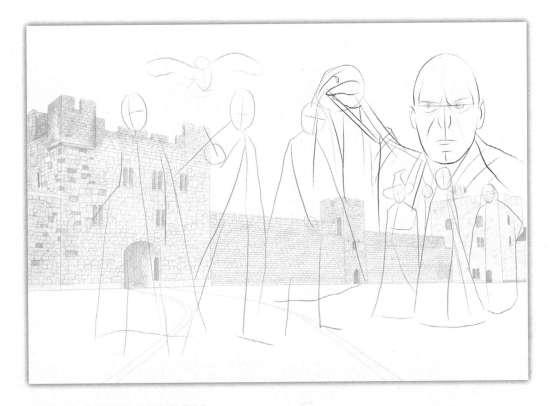

FINAL COMPOSITION

As you get ready to add the figures, remember that the light source has to be the same for everyone. So you'll have to make some adjustments to figures you've already drawn. (Also, make sure that no one is standing on someone's foot!)

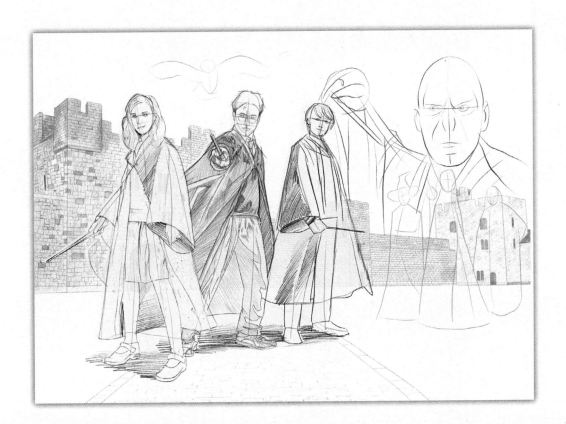

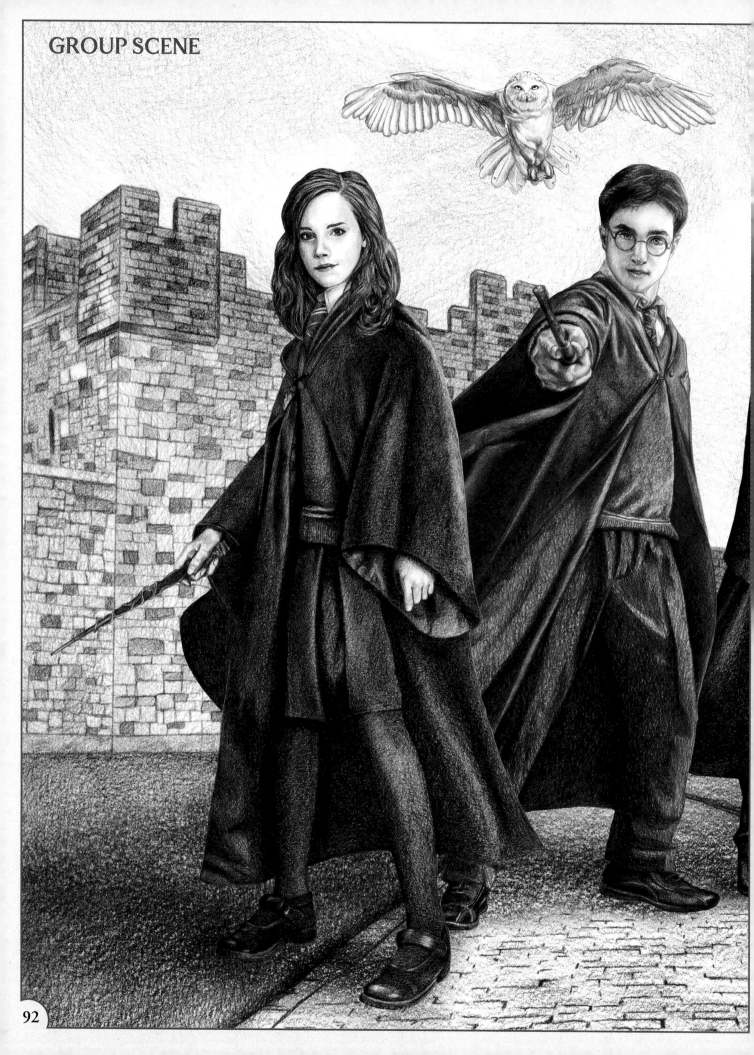

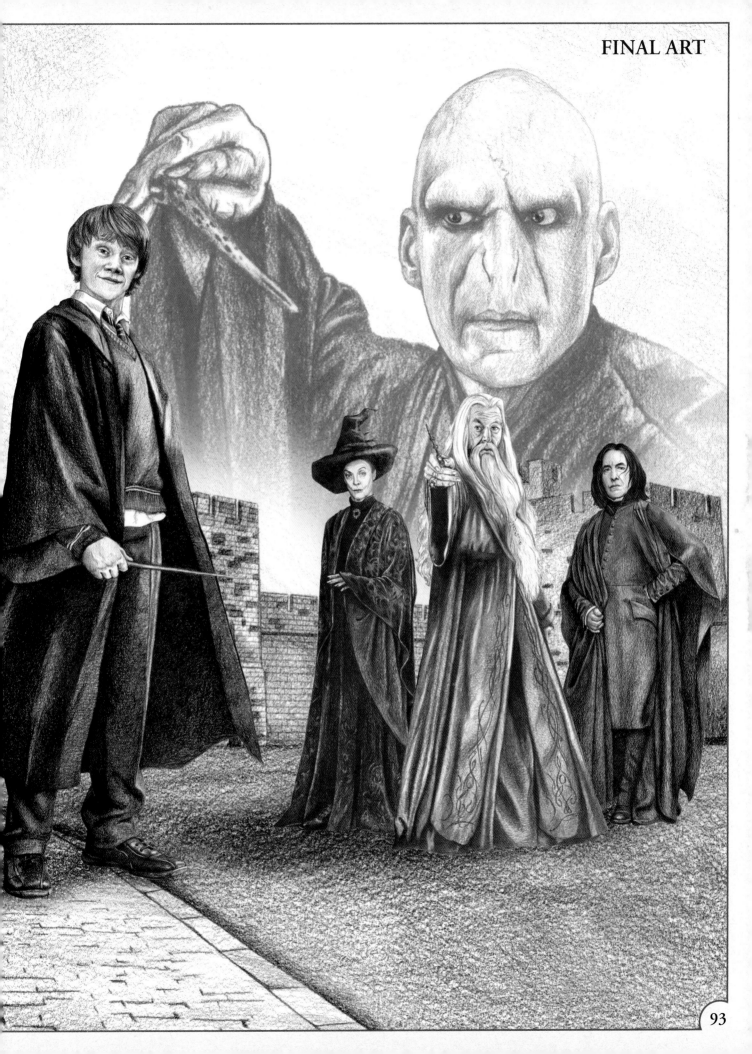

Corina St. Martin is a fantasy artist, sculptor, and children's book illustrator with a degree in graphic design from the School of Advertising Art in Kettering, Ohio. She was born in Rockledge, Florida, and grew up both in Florida and in southern Wisconsin. After several moves, she landed in Richmond, Indiana with her partner Julie and their semi-domesticated wild things. For over twenty years, Corina has worked in various fields of art. Animals play a dominant role in Corina's work, whether it be two dimensional or sculpture. A lifelong fascination with our planet's various lifeforms began early on through trips to various zoos, aquariums, the ocean, and museums, along with her grandparents' *National Geographic* and *Smithsonian* magazine subscriptions. These magical places, as well as a steady diet of books, laid the groundwork for the fantastic to grow in her imagination.

Steve Behling would probably not last very long in a fight against Lord Voldemort, but he does possess all the necessary skills to be an excellent Quidditch spectator. Regardless, he's the writer of many books, including *Bill & Ted's Excellent Adventure: The Guide to a Bodacious Life*, the original middle-grade novel *Onward: The Search for the Phoenix Gem*, and many how-to-draw books featuring Marvel Super Heroes such as Spider-Man, Iron Man, and the X-Men. He also maintains www.thatsbelievable.com, a website full of made-up facts and essential weirdness. Steve lives in a top-secret subterranean lair with his wife, two human children, and three-legged wonder beagle, Loomis.

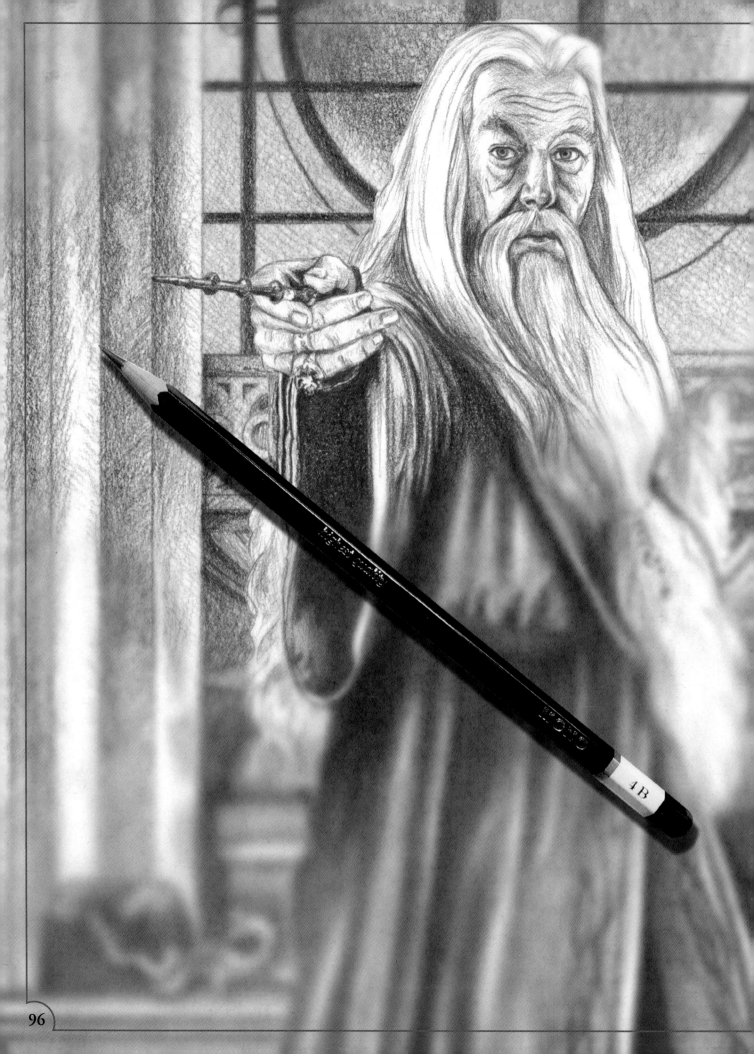